IMAGES
of Rail

CHICAGO AND THE ILLINOIS CENTRAL RAILROAD

D1600179

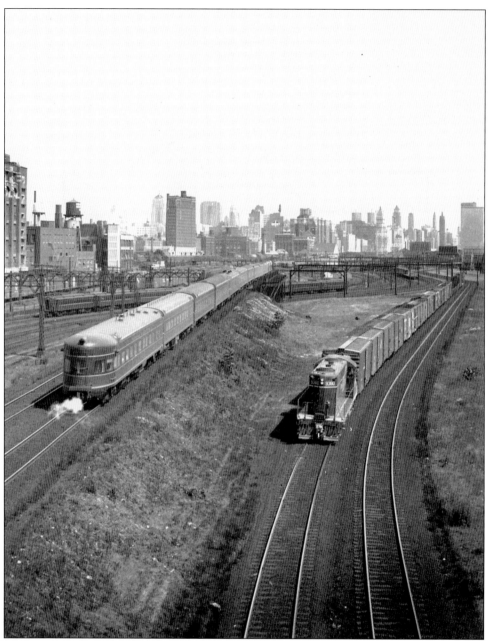

Train operations on the Illinois Central Railroad in Chicago are skillfully illustrated in this publicity photograph taken at Twenty-third Street in the early 1960s. To the right is a short freight train. In the middle is the *Panama Limited*, arriving in town after its overnight run from New Orleans. In the background is a suburban train. Today most of this area is covered by McCormick Place. (Illinois Central Railroad.)

On the cover: A group of schoolchildren pose at Chicago's Central Station around 1960. In the background is E8A 4026. Train rides were once a common activity for schoolchildren. (Illinois Central Railroad.)

IMAGES
of Rail

CHICAGO AND THE ILLINOIS CENTRAL RAILROAD

Clifford J. Downey

ARCADIA
PUBLISHING

Copyright © 2007 by Clifford J. Downey
ISBN 978-0-7385-5074-9

Published by Arcadia Publishing
Charleston SC, Chicago IL, Portsmouth NH, San Francisco CA

Printed in the United States of America

Library of Congress Catalog Card Number: 2007925809

For all general information contact Arcadia Publishing at:
Telephone 843-853-2070
Fax 843-853-0044
E-mail sales@arcadiapublishing.com
For customer service and orders:
Toll-Free 1-888-313-2665

Visit us on the Internet at www.arcadiapublishing.com

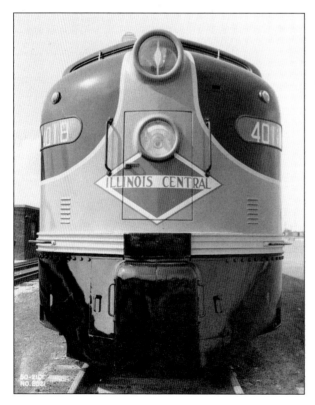

Illinois Central E8A 4018 shows off its stout "bull dog" nose in this photograph taken in June 1950, before the locomotive was delivered. Most diesel-electric locomotives bought by the Illinois Central, including the 4018, were built by the Electro-Motive Division (EMD) of General Motors. EMD's main plant was in LaGrange, a Chicago suburb. (EMD General Motors.)

CONTENTS

ACKNOWLEDGMENTS

Unless noted otherwise, all photographs in this book came from the Illinois Central Railroad. Using both its own staff as well as commercial photographers, in the late 1800s, the railroad began taking photographs of new cars, locomotives, buildings, track construction, and special events, as well as ordinary day-to-day activities on the railroad.

Many photographs were used for advertising or publicity purposes. Some photographs were used by the engineering department during construction projects, while others were used by the legal department to provide a visible record of accidents or wrecks. Regardless of their purpose, these photographs provide an intriguing look at the railroad and its activities.

I began acquiring these photographs back in the early 1980s when I first became interested in the Illinois Central. Some of the photographs were purchased at railroad swap meets, through magazine classified advertisements, or eBay. Numerous photographs were given to me by retired railroad employees, while others were part of collections that I purchased.

I would like to thank the late Bruce R. Meyer for permitting me to use several of his photographs. In my opinion, Mr. Meyer was a fine photographer who did not receive all the recognition he deserved. Not only was he creative with his composition, he also photographed many subjects that were ignored by other photographers. Mr. Meyer was also very generous in sharing his work with others.

Other photographs came from the collections of Louis A. Marre, M. D. McCarter, and the late Bob Schrepfer, Charles T. Felstead, and John B. Allen. Several photographs from my own collection also appear here. Unfortunately, when I acquired these particular prints and negatives, they did not have a notation of the photographer's name. I regret that the photographer's names are not being published alongside their work.

The archives at the Illinois Central Railroad Historical Society (ICHS) proved invaluable while writing the captions. Anyone with an interest in the Illinois Central Railroad is encouraged to join the ICHS. Members receive a quarterly magazine, and each year the society has a convention. The Illinois Central Historical Society can be reached at P.O. Box 288, Paxton, Illinois, 60957.

INTRODUCTION

Since the late 1800s, Chicago has been regarded as the railroad capital of the United States. Chicago had more railroads and more miles of track than any other city. It was nearly impossible to go more than a half dozen city blocks without running into a set of railroad tracks.

One of the most important railroads operating into Chicago was the Illinois Central Railroad. The Illinois Central operated two routes out of Chicago. The busiest of these routes was the Main Line. Beginning at South Water Street, on the banks of the Chicago River, this line ran south through suburbs such as Hyde Park, Kensington, and Mateson. Once out of the metropolitan area, this route passed through Kankakee, Champaign, Carbondale, and Centralia, and continued onward to Memphis, Tennessee, and New Orleans.

Illinois Central's second route in Chicago was the Western Lines. This route also began at South Water Street and passed through Berwyn, Broadview, and Cicero before continuing west to Iowa. In Iowa the route split several times, with branches going to cities such as Madison, Wisconsin; Cedar Rapids, Iowa; Albert Lea, Minnesota; Sioux City, Iowa; and Sioux Falls, South Dakota. The main trunk of the Western Lines terminated in Omaha, Nebraska. A wide variety of meat, agricultural, and manufactured products flowed into Chicago over the Western Lines.

Planning for the Illinois Central began back in the 1840s, when the railroad industry was in its infancy. There was a great desire to develop the interior portion of the state. But these efforts were hampered by poor transportation. A handful of rivers and canals dissected the central part of the state, but shipping rates were high. Droughts and floods also made river transportation a risky proposition.

Politicians and businessmen began pushing for a railroad. Since the new railroad was to be built north to south through the central part of Illinois, it was only natural that the railroad would be called the Illinois Central Railroad. When the railroad was first envisioned, only one route was planned. It would stretch from Cairo, at the far southern tip of Illinois, north to Freeport, and then westward to Dunleith (now known as East Dubuque). This line was called the Charter Line, since it was the first route proposed by company.

Several influential politicians objected to the idea of building just this one route. They felt that the railroad should also serve the growing city of Chicago, which at that time had limited rail service. As a compromise, proponents of the Illinois Central agreed to build a line to Chicago. Known as the Chicago Branch, this 250-mile line split away from the Charter Line at Centralia (founded by and named for the railroad). It then headed northeast toward Chicago.

Plans for Illinois Central were ambitious. The railroad would stretch for 705 miles, making it the longest railroad in the world at the time. Construction was estimated to cost over

$16 million, an astronomical sum of money in those days. But how would it be paid for? When Illinois was admitted to the union in 1818, the United States government retained title to most land in the new state. Politicians advocated that this land could be used to build the railroad. Part of the land would provide the right-of-way for the new railroad, while the rest would be sold to pay construction costs. After much debate, in September 1850, a bill was signed by Pres. Millard Fillmore granting the State of Illinois more than 2.5 million acres of federal land down the central part of Illinois. Most of this land was later given to the Illinois Central, making it the first "land grant" railroad in the United States.

After many years of dreaming and planning, the Illinois Central Railroad was chartered on February 10, 1851. Groundbreaking ceremonies were held at Cairo on December 23, 1851. Another groundbreaking was held the same day near Lake Calumet (later renamed Kensington). From here, track gangs began working northward toward Chicago. Crews also began laying track a short distance eastward to the Indiana state line and a connection with the Michigan Central Railroad.

In May 1852, track gangs reached the southern city limits of Chicago but then had to stop while legal arrangements were completed to lay track within the city of Chicago itself. At this point the Illinois Central had 14 miles of track, stretching from the Indiana state line to the southern city limits of Chicago. On May 22, 1852, the Illinois Central inaugurated passenger train service over this segment of track. This was the first section of track anywhere on the Illinois Central to enter service.

Later in 1852 the Illinois Central hammered out an agreement to lay tracks inside Chicago, and the tracks were quickly laid into the city. Passenger and freight terminals were established at Randolph Street and South Water Street, and business quickly boomed. The railroad's headquarters were also established in the city.

For several years the Illinois Central trackage at Chicago was isolated from the rest of the railroad. The Cairo-Dunleith portion of the railroad was regarded as the most important segment, and construction was initially focused on that part. After this route was complete in June 1855, attention shifted to completing the Chicago Branch. This task was completed on September 27, 1856, when the last spike was driven just south of Effingham at a station called Mason. This newly established station was named after Roswell B. Mason, the railroad's chief engineer. In 1869, Mason was elected mayor of Chicago. Near the end of his single two-year term, the Great Chicago Fire of October 8-9, 1871, destroyed most of the city, and Mason helped spearhead the city's reconstruction.

Construction of the Illinois Central ultimately cost $26 million, or approximately $37,600 per mile. But the investment and hard work was worth it. Towns and villages quickly popped up all along the railroad. This new development had an impact on the Illinois Central's facilities in Chicago. The railroad quickly outgrew the passenger and freight terminals built in 1852 when it first entered Chicago. In response, the railroad constructed Great Central Station along South Water Street. This building cost $250,000 and when completed was Chicago's largest building. In addition to the Illinois Central, the station served the Chicago, Burlington and Quincy Railroad and the Michigan Central Railroad.

But even Great Central Station proved to be too small as traffic boomed in the mid-1800s. In 1872, the Illinois Central formed an alliance with two Southern railroads, the Mississippi Central Railroad and the New Orleans, Jackson and Great Northern Railroad (both railroads were later acquired by the Illinois Central). Together these three railroads provided the first rail link between Chicago and New Orleans. The railroads were connected via a ferry across the Ohio River at Cairo. Even though the ferry connection was slow, the rail link was much faster, and cheaper, than the old routes via riverboats. Almost overnight the volume of passengers and freight arriving in Chicago from the Deep South skyrocketed.

Just like most of the city of Chicago, the Illinois Central suffered during the Great Chicago Fire of October 9, 1871. The train shed at Great Central Station was destroyed, and much of the station itself was damaged. A temporary station was established at Twenty-second Street while

Great Central was being repaired. The train shed was not repaired. Instead its burned-out walls stood until the train shed and station were demolished in the 1890s.

The Chicago fire impacted the Illinois Central in other ways. Much of the debris from the fire was dumped into Lake Michigan along Illinois Central's tracks. The trestle that provided access to downtown Chicago formerly was about 100 yards offshore. After debris from the fire had been dumped in the lake, the railroad's tracks were on solid ground.

After the fire, many families relocated to the southern suburbs. This prompted the railroad to expand its suburban service farther south and increase the number of suburban trains. During 1870 the suburban trains were carrying an average of 650 passengers per day, and by 1880 that figure had risen to 3,800 passengers daily. By 1890 suburban trains were running all the way to Homewood, and the trains were carrying an average of 13,400 passengers per day.

The suburban trains terminated at Great Central Station, along with Illinois Central's intercity passenger trains. The station was also shared with two subsidiaries of the New York Central system: the Michigan Central Railroad and the Cincinnati, Chicago and St. Louis Railway, better known as the Big Four. By the early 1890s, these three railroads were operating nearly 100 intercity passenger trains each day. Combined with the suburban trains, this made the Great Central Station one of the busiest railroad stations in Chicago.

The congestion at Great Central could not be ignored as Chicago began planning for the World's Columbian Exposition of 1893. The exposition was to be held in Jackson Park next to Illinois Central's tracks, and most attendees would arrive via Illinois Central trains. In the spring of 1892, the railroad began construction of a new railroad terminal and headquarters at Michigan Avenue and Park Row (later renamed Eleventh Place). Known as Central Station, the new $1.2 million structure opened on April 17, 1893, just in time for the Columbian Exposition. When the building was constructed, it was literally right on the shore of Lake Michigan. In later years, approximately 1,000 feet of the lake was filled next to Central Station.

During the early 1900s, the Illinois Central invested heavily in new track, cars, and locomotives. The entire Main Line between Chicago and New Orleans was double tracked. At the time, the Illinois Central was the only railroad with a direct route between the two cities, and the railroad had a near monopoly on freight and passengers traveling this route. Most of this route was flat and straight, allowing trains to move at high speeds.

Chicago's importance to the Illinois Central is illustrated by these figures taken from the book *Organization and Traffic of the Illinois Central System,* published in 1938 by the railroad. In 1936, Chicago generated nearly 25 percent of all freight revenue on the railroad. The Illinois Central handled nearly two million freight cars in Chicago that year, and over one-third of all coal hauled by the railroad was shipped to Chicago. Each day the railroad operated 456 daily suburban trains and for the year carried over 24 million suburban passengers. Approximately 70 passenger trains arrived and departed each day from Central Station.

By the mid-1900s, the Illinois Central was facing intense competition from the trucking industry for its freight traffic, while airlines and the automobile were siphoning away its passengers. In 1962, the railroad formed a parent company called Illinois Central Industries, renamed IC Industries in 1975. The purpose was to diversify the company in an effort to remain profitable. Initially the new company bought firms that built industrial products. But in the 1970s, IC Industries shifted its attention to the consumer goods market and bought companies such as Perfect Plus Hosiery, Midas, Whitman's Chocolates, Pet Company (evaporated milk), Old El Paso Mexican Foods, and Pepsi General Bottlers of Chicago.

In an attempt to remain profitable, the Illinois Central merged with the Gulf, Mobile and Ohio Railroad to form the Illinois Central Gulf Railroad. Sadly, the merger did not produce the results that had been expected. During the 1970s and 1980s, large segments of the railroad were abandoned or sold. Most of the Charter Line between Centralia and Freeport was torn up. In 1985, the Western Lines between Chicago and Iowa was sold to the Chicago, Central and Pacific Railroad. Then, in 1986, the Paducah and Louisville Railway bought most of the old Kentucky Division, the source for much of the coal hauled by the Illinois Central.

Once these sales were completed, the Illinois Central Gulf had essentially been trimmed down to a railroad operating between Chicago and New Orleans. Whitman Industries (the successor to IC Industries) tried to find a buyer for the Illinois Central Gulf, but without luck. So in 1988, the railroad was spun off as an independent company and renamed Illinois Central Railroad. Headquarters were kept in Chicago, just as they had been since the 1850s.

In March 1989, the newly independent railroad was purchased by the Prospect Group, a buyout firm with ties to the railroad industry. Edward Moyers was then installed as president of the railroad. He transformed the railroad by trimming payroll, selling excess locomotives and cars, and reducing overhead costs wherever possible. Moyers caused a stir by removing one of the double tracks between Chicago and New Orleans. But thanks to a new signaling system and lengthened sidings, the railroad was able to move as many trains as it had before.

Moyers retired in 1993 and was succeeded by E. Hunter Harrison, who continued Moyers's goal of reducing costs and improving efficiency. The Illinois Central became known as one of the best-run railroads in the industry, and it was not uncommon for rumors to circulate that the railroad was about to be bought. In 1994, the road announced plans to merge with the Kansas City Southern, but those plans died after a few months. Then on February 10, 1998, the Illinois Central signed a merger agreement with the Canadian National Railway. The Canadian and United States governments gave their approval, and on July 1, 1999, the Illinois Central was formally merged into the Canadian National. The new railroad was initially called Canadian National-Illinois Central, but now is known simply as Canadian National.

E. Hunter Harrison, the last president of the Illinois Central while it was an independent railroad, initially became chief operating officer of the Canadian National after the merger. Then on January 1, 2003, Harrison was promoted to president and chief executive officer of Canadian National Railway. During his tenure, Harrison has aggressively campaigned to make the Canadian National one of the most dependable and efficient railroads in the industry.

Although the "old" Illinois Central Railroad no longer exists, its legacy still remains strong in Chicago. Many locomotives and cars still carry Illinois Central lettering. Eventually all of this equipment will either be repainted or scrapped. But even then, rail fans, employees, and the public will still have fond memories of the railroad known as the "Main Line of Mid-America."

One

EARLY YEARS

The Illinois Central Railroad ran into significant obstacles while trying to lay its track within the city of Chicago. At first, the railroad wanted to lay its tracks several miles from the lakefront. But most land along this route had already been taken by a rival road, the Rock Island. So the Illinois Central began considering the idea of building along Michigan Avenue, right on the shores of Lake Michigan. But this idea was opposed by the wealthy residents living along the lakefront.

As a compromise, the railroad agreed to build a trestle and breakwater about 100 yards offshore in Lake Michigan. This trestle stretched from Randolph Street to Twenty-second Street. The trestle kept Illinois Central's trains out of the front yards of the wealthy landowners, while the breakwater served to protect the shoreline from the violent storms that frequently blew in from the lake.

Once it had secured an entrance into the city, the railroad purchased part of the old Fort Dearborn property near the mouth of the Chicago River for construction of passenger and freight facilities. In 1852, the railroad opened a passenger terminal along South Water Street. But this facility soon became overcrowded and, in 1856, was replaced by Great Central Station, also located along South Water Street. Several freight houses were built near Great Central Station, and the area quickly became clogged with railroad tracks.

Illinois Central's freight and passenger business in Chicago grew rapidly in the late 1800s. This new business put a strain on the railroad's facilities, forcing the railroad to expand its freight yards, add extra tracks to its Main Line, and construct a new passenger terminal. The railroad was also forced by the city to elevate its tracks above street level to end the carnage caused by trains colliding with horse-drawn wagons and pedestrians. These construction projects were expensive, but the Illinois Central entered the 20th century with some of the most modern facilities in the Chicago area.

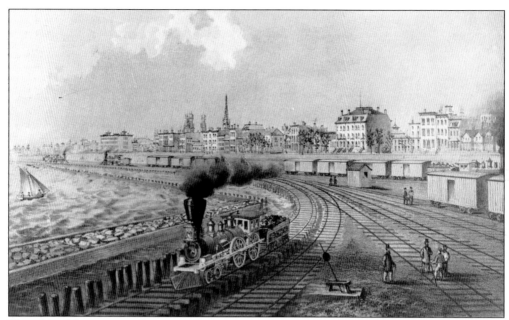

This fanciful painting illustrates Illinois Central's trackage near downtown Chicago as it existed in the 1850s. At that time Illinois Central's passenger and freight facilities in downtown Chicago were confined to a narrow strip of land along the shores of Lake Michigan on the south side of South Water Street. The congestion eased a bit in 1893 with the construction of Central Station.

WANTED!

3,000 LABORERS

On the 12th Division of the

ILLINOIS CENTRAL RAILROAD

Wages, $1.25 per Day.

Fare, from New-York, only - - $4.75

By Railroad and Steamboat, to the work in the
State of Illinois.

Constant employment for two years or more given. Good board can be obtained at two dollars per week.

This is a rare chance for persons to go West, being sure of permanent employment in a healthy climate, where land can be bought cheap, and for fertility is not surpassed in any part of the Union.

Men with families preferred.

For further information in regard to it, call at the Central Railroad Office,

173 BROADWAY,

CORNER OF COURTLANDT ST.

NEW-YORK.

R. B. MASON, Chief Engineer.

H. PHELPS, Agent,

July, 1853.

Constructing the Illinois Central Railroad was difficult. One of the most difficult tasks was finding enough laborers. This 1853 advertisement was posted throughout New York City in the early 1850s. Pay is listed as $1.25 per day, and the advertisement states that a worker can expect at least two years of steady employment. Note that men with families were preferred because these men were viewed as more dependable.

Illinois Central was the nation's first land grant railroad. The United States government gave the State of Illinois 2.5 million acres of land to build the railroad. The railroad was to sell this land and use the proceeds to pay for construction. This 1867 advertisement extolled the virtues of living on the Illinois prairie. The rich, fertile soil is repeatedly mentioned, but the harsh winter weather and desolation are ignored.

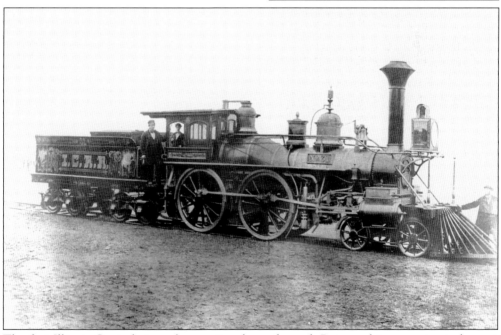

The first Illinois Central steam locomotives burned wood. But wood is expensive to harvest and transport and is not a very efficient fuel source. In the mid-1850s, the railroad began experimenting with coal as a locomotive fuel. The experiments were a success, and by the early 1870s all Illinois Central steam locomotives were burning coal.

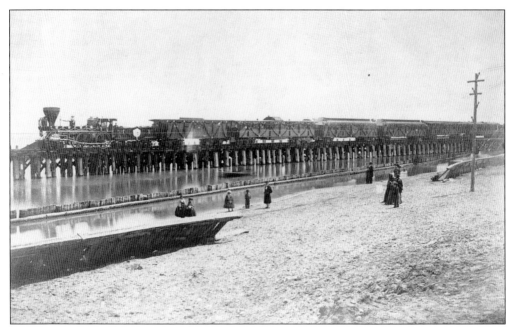

After Abraham Lincoln was assassinated on April 14, 1865, his body was transported by railroad back to Springfield, Illinois, for burial. On April 21, the train left Washington, D.C., and arrived in Chicago on May 1. Between Kensington and downtown Chicago the train traveled over the Illinois Central. The train was photographed on the Lake Michigan trestle used by the Illinois Central to enter downtown Chicago.

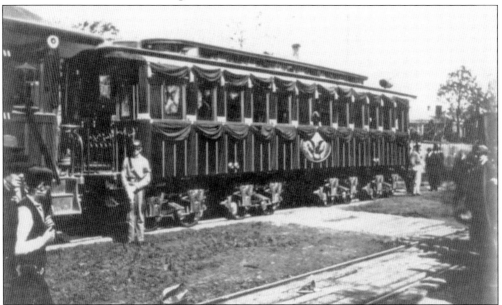

Abraham Lincoln's body was carried aboard this car. Also carried on this car was the coffin of William (Willie) Lincoln, the third son of Abraham and Mary Lincoln. Willie died in 1862 at age 11 while his father was president. He was originally buried in Georgetown, Maryland. After his father was assassinated, Willie was exhumed and his body was returned to Springfield to be buried with his father.

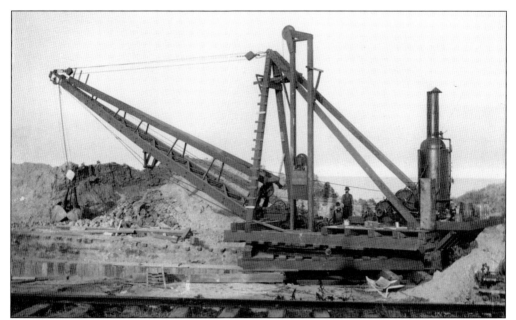

In the 1890s, the Illinois Central filled in numerous acres of Lake Michigan. Once this project was complete the Illinois Central's Main Line into downtown Chicago was on solid earth. Originally this line was on a trestle several hundred yards offshore. This steam-powered shovel was photographed around 1900. Machines of this type were very dangerous due to their exposed gears, pulleys, and levers.

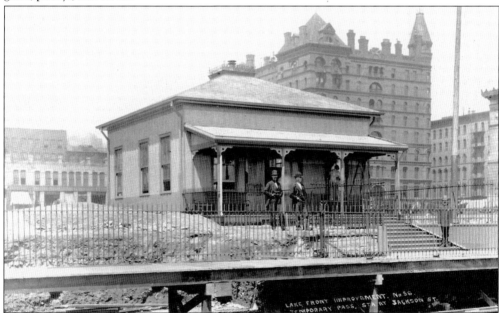

As part of the Lake Michigan reclamation project, the Illinois Central rebuilt and reconfigured virtually all of its trackage in downtown Chicago. During the reconstruction project, a temporary passenger station was constructed at Jackson Street, just north of Grant Park, as seen in this May 23, 1896, photograph. This station was used only for suburban trains. Intercity passenger trains terminated a few blocks south at Central Station.

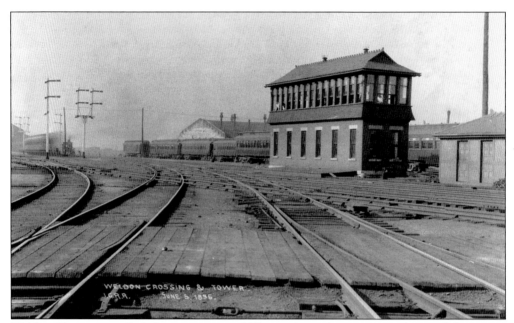

Weldon Tower controlled the movement of Illinois Central trains in and out of downtown Chicago. This two-story brick structure was located just south of Central Station, which is just out of view to the left. The tower was photographed on June 5, 1896. At the time, approximately 200 suburban trains passed the tower each workday, along with 100 passenger trains and approximately 60 freight trains.

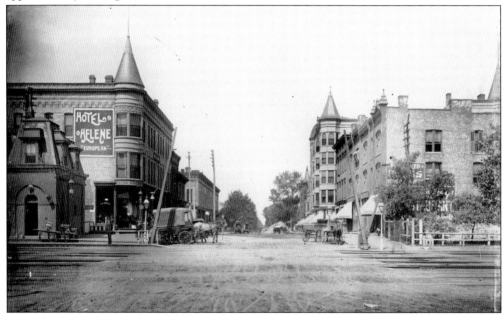

This photograph was taken on July 1, 1892, along Illinois Central's Main Line at Fifty-third Street. Looking westward across the tracks, the Hotel Helene is seen at left. A pair of horse-drawn American Express delivery wagons are waiting in front. Across the street are a restaurant, bakery, dry goods store, and a doctors' office. Within a few years the tracks will be elevated above street level.

Grand Crossing at Seventy-fifth Street was appropriately named. Here the Illinois Central's Main Line crossed the Pennsylvania Railroad (PRR), New York Central Railroad (NYC), and the Nickel Plate Road. In this photograph dated November 9, 1896, the crossing was protected by wooden gates. The PRR and NYC tracks were elevated in 1912 to reduce congestion and stop the frequent wrecks that happened here.

Traffic on the Illinois Central in Chicago grew rapidly during the late 1800s, especially on the Main Line headed south. This caused a lot of congestion, as illustrated by this photograph taken at Harvey around 1900. The two tracks at far left, next to the depot, were used by passenger and suburban trains, while the three tracks at right were used by freight trains.

This photograph of the wooden depot at Kensington (115th Street) was taken in April 1890. Other than a handful of gentlemen posing for their portrait, little action can be seen. But looks can be deceiving, for in 1890 the Illinois Central was operating approximately 100 suburban, passenger, and freight trains through Kensington each day.

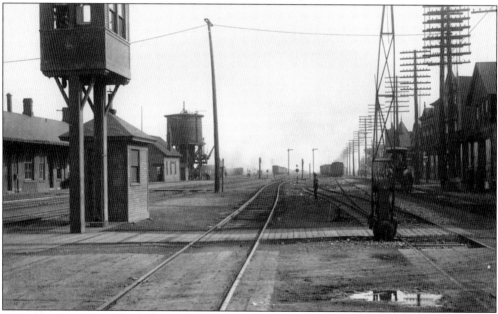

Kensington and the surrounding area grew rapidly during the 1890s and early 1900s. During this period the Illinois Central expanded its facilities to meet the needs of local residents and businesses. This 1914 photograph shows that the wooden depot has been replaced by a brick depot partly visible at left. A wooden crossing tower is in place to protect pedestrians and vehicles crossing the railroad.

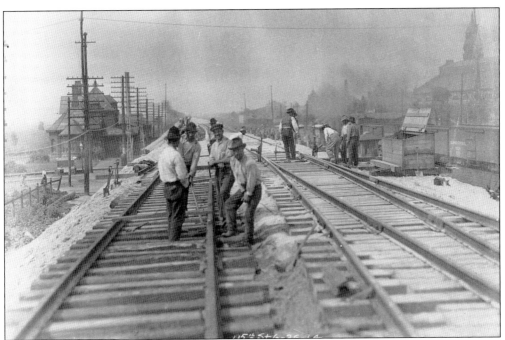

In the early 1900s, a great deal of political pressure was put on the Illinois Central to elevate its tracks throughout the entire Chicago area. The railroad was happy to oblige, for trains had to slow down for crossings with city streets and other railroads. This photograph taken on June 26, 1914, shows a track gang hard at work on the newly elevated track at Kensington (above). Although the rails and ties are in place, the track is not in service yet. Mechanized track-laying machines had yet to be developed so the work is being done the old-fashioned way with picks, axes, shovels, and sledgehammers. The new line was complete and open for business when the photograph below was taken on August 7, 1914. Rails and ties from the old line are being salvaged for reuse.

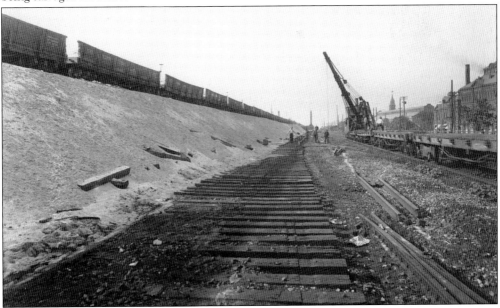

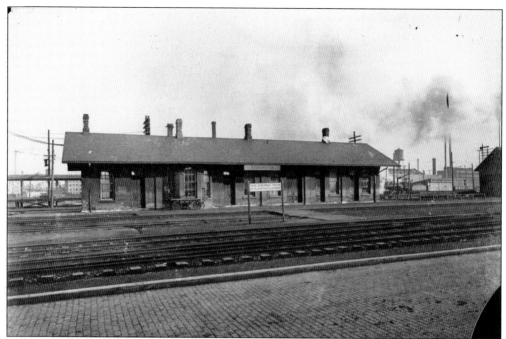

As part of the track elevation project a new depot was built at Kensington. The old brick depot is seen in 1914 (above). The sign on the front of the building advised that Chicago was 14 miles to the north, while New Orleans was 898 miles to the south. This depot was used only for intercity passenger trains. Suburban trains stopped at a nearby wooden platform. The new depot is seen in the photograph below. The waiting room was below track level, and passengers had to climb a set of stairs to reach the tracks. Baggage and heavy freight were lifted to track level on an elevator located on the north side of the building.

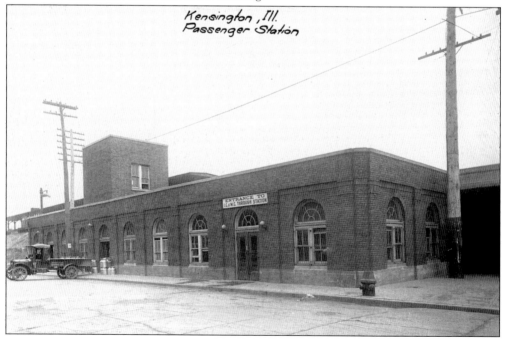

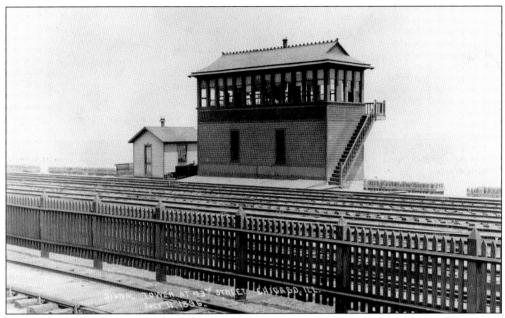

To prevent collisions the Illinois Central built several signal towers throughout Chicago to control traffic. This wooden signal tower at Forty-third Street helped control the heavy flow of traffic heading in and out of downtown Chicago. Using timetables plus train orders received via telegraph from dispatchers, the tower men would set the signals and route trains onto different tracks as needed. The tower was photographed on July 11, 1896.

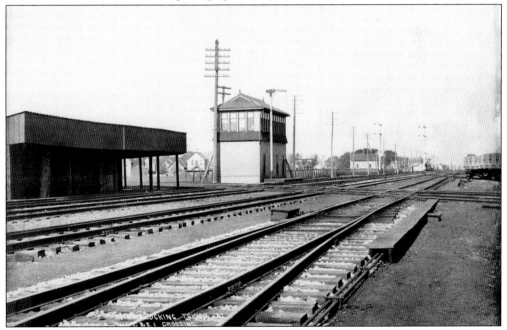

At Kensington the Chicago and Eastern Illinois Railroad's Main Line south to Danville crossed the Illinois Central. In this 1896 photograph the Illinois Central's Main Line is running from left to right. The covered shed at left was for the protection of commuters as they waited for their train.

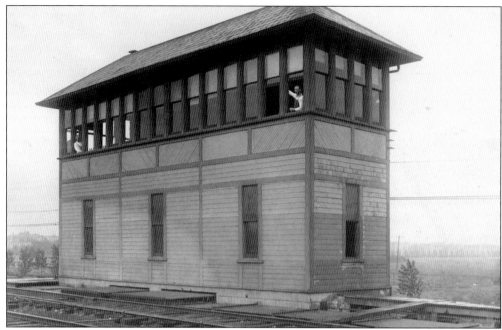

The junction between Illinois Central's Main Line and the South Chicago branch was guarded by this sturdy wooden structure, seen in a 1903 photograph. The World's Columbian Exposition was held in 1893 in nearby Jackson Park, and this tower helped control the passage of the hundreds of special trains that ran to the site each day.

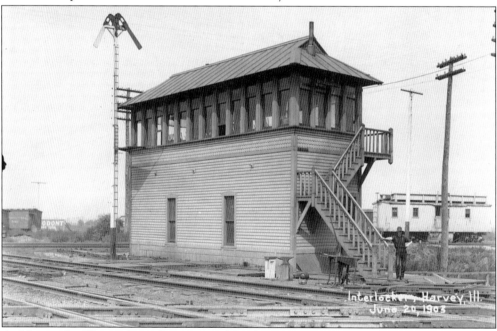

At Harvey the Illinois Central was crossed by the Grand Trunk Western and Baltimore and Ohio Chicago Terminal railroads. This interlocking tower controlled train movements through the busy junction. The term *interlocking* referred to the fact that when a clear signal was given to trains on one track, the signals on crossing tracks could only show a stop signal.

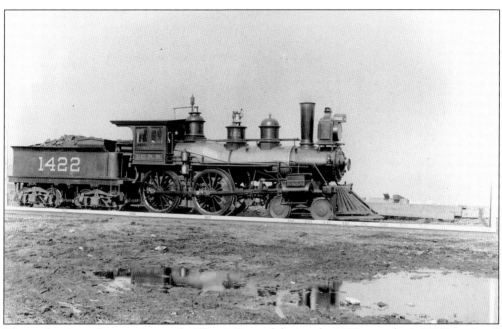

The predominant locomotive on the Illinois Central during the 1800s was the 4-4-0 "American" type. These locomotives had four small pilot wheels and four drivers. Illinois Central's first locomotive was a 4-4-0, and the railroad eventually owned more than 700 4-4-0s. No. 1422 (above) was built in May 1855 by the Rogers Locomotive Works. It was originally numbered IC 50, and weighed 56,000 pounds. In 1876, it was renumbered IC 1422 and retired between 1890 and 1896. No. 906 was one of the last 4-4-0s purchased by the Illinois Central. This locomotive was photographed in Chicago in 1890, shortly after it was built by the Brooks Locomotive Works. Renumbered first as 1906 and then as 4906, this locomotive was retired in 1940 after 50 years of service. (Above, Clifford J. Downey collection; below, John B. Allen collection.)

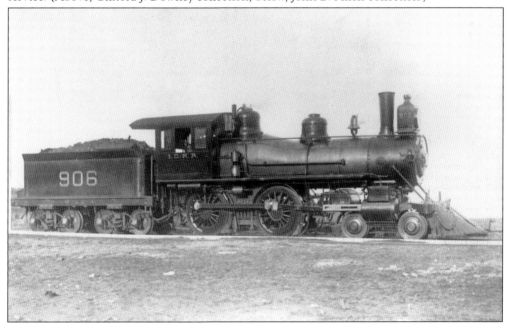

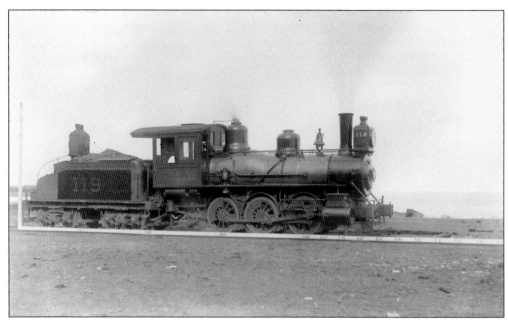

The 0-6-0 No. 119 was typical of the switch locomotives used in Chicago during the late 1800s. This locomotive was built in February 1891 by the Brooks Locomotive Works of Dunkirk, New York. In July 1929, this locomotive was sold to Briggs and Turivas, a Chicago-based company that specialized in reselling or scrapping old railroad equipment. (Clifford J. Downey collection.)

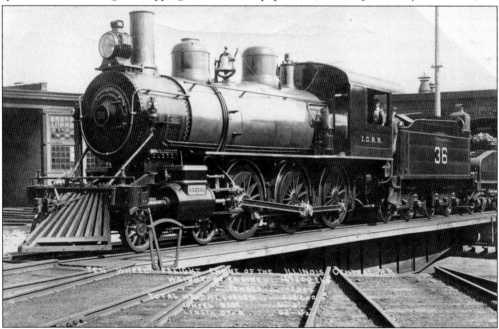

Between 1898 and 1901, the Illinois Central bought 64 new 4-6-0 ten-wheelers. Numbered 1–64, these locomotives were regarded as the Illinois Central's most powerful locomotives at the time. They were soon eclipsed in power and efficiency, and in 1921 and 1922, all but seven were sold to the Mexican National Railway. On October 7, 1899, No. 36 poses at the Weldon Shops shortly after delivery. (Clifford J. Downey collection.)

Two

CENTRAL STATION

By the late 1800s, the Illinois Central desperately needed a new passenger terminal in Chicago. Great Central Station, built in 1856 along South Water Street, was woefully overcrowded and quickly showing its age. As the city of Chicago began planning for the World's Columbian Exposition of 1893, the railroad also began planning a new passenger terminal.

The new station, called Central Station, was to be built along the shores of Lake Michigan at Michigan Avenue and Park Row (later renamed Eleventh Place). Since there was very little land available at this site, the new station had to be tall and narrow. Architect Bradford Gilbert was hired to design the station itself, while the attached train shed was designed by H. W. Parkhurst, the railroad's bridge engineer. The train shed covered six tracks and was 610 feet long and 140 feet wide. When constructed, it was said to be the world's largest train shed.

In its original form Central Station was a magnificent structure to look at. The nine-story building was built according to the Romanesque style of architecture and featured an elegant clock tower. Passengers, though, grumbled at the placement of the waiting room above the tracks.

When constructed, only a small portion of Central Station was actually used for passenger operations. Most of the building was occupied by the railroad's headquarters. Central Station quickly became crowded and in 1902–1903 the 10-story annex was added to the southwest corner.

Unfortunately, the annex was built using a different architectural style than Central Station. The station's appearance suffered even more in 1907 when the railroad purchased the Dowie Building at Twelfth Street and Michigan Avenue. When the city of Chicago widened Roosevelt Road in 1923, the Dowie Building had to be moved. An enclosed walkway was constructed to link the third floors of the Dowie Building and the annex.

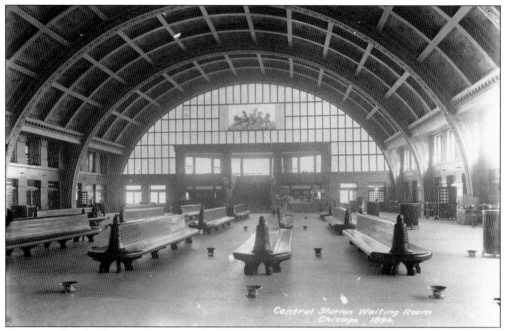

Spittoons dot the floor in this 1894 photograph of the waiting room at Central Station. This view is looking toward the east wall. When the station was built this wall was all glass. In the middle of this glass wall was a stained-glass mural depicting five horses being driven by a charioteer. Below the mural was a balcony overlooking Lake Michigan.

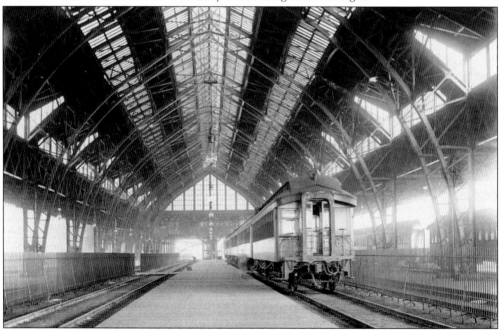

When it was built, Central Station had one of the grandest train sheds of any passenger terminal in Chicago. The train shed covered six tracks, was 140 feet wide, 610 feet long, and 62 feet tall. Skylights in the roof let in abundant natural light, as seen in this photograph taken around 1895. (Clifford J. Downey collection.)

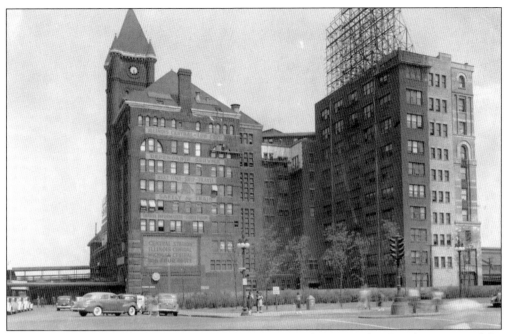

This photograph of the west side of Central Station was taken around 1950. The portion of the building on the left side of this photograph, including the clock tower, was built in 1893. The 10-story annex with the massive sign on the roof was built in 1902 and 1903. Out of view to the right is the Dowie Building. (Clifford J. Downey collection.)

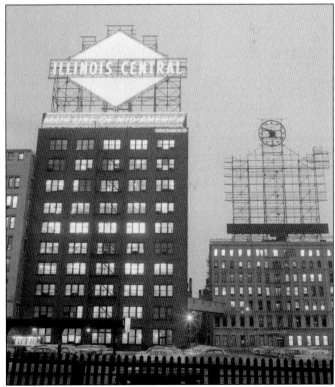

In this photograph taken around 1960, the Central Station annex stands to the left with a large Illinois Central sign on the roof. To the right is the shorter Dowie Building. It may not be evident in this photograph, but the two buildings were on opposite sides of Roosevelt Road. An enclosed walkway connected the third floors of each building. (Clifford J. Downey collection.)

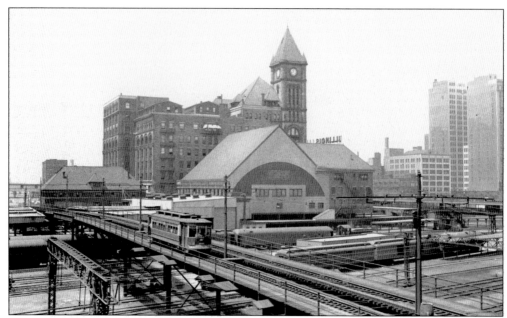

The east side of Central Station is seen on a muggy, overcast day. At the center of the photograph is the waiting room with its massive angled roof. This photograph is undated but is believed to date from the late 1940s. The streetcar is running on a trestle built to provide access to the 1933–1934 world's fair, which was held along the lakefront between Twelfth and Thirty-ninth Streets.

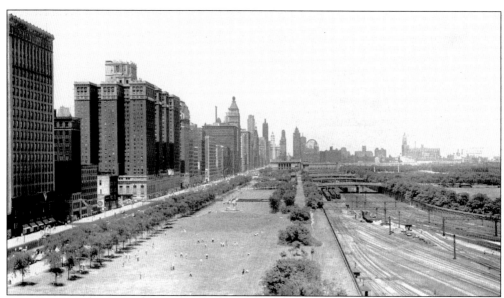

A commanding view of Chicago and the lakefront could be enjoyed from the upper floors of Central Station. This view is looking due north around 1940. Michigan Avenue is to the left, and Grant Park is in the center. Illinois Central's electrified suburban tracks are to the right. After swinging around the east side of Central Station the tracks straightened out before terminating at Randolph Street station. (Clifford J. Downey collection.)

Central Station was listed as a station along Illinois Central's suburban line. But that was a bit misleading for suburban trains did not run directly into the station. Instead the suburban trains stopped at a simple wooden platform on the east side of the station. This platform is visible on the right side of this photograph taken around 1950. (Clifford J. Downey collection.)

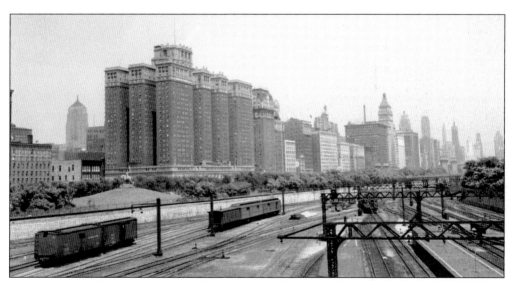

The elevated walkway connecting Central Station and the adjacent suburban platform was a great place to photograph trains and the Chicago skyline. In the background is the Stevens Hotel. Over the years the grand hotel was used as a backdrop for numerous Illinois Central publicity photographs. The hotel opened in 1927 and was built by Ernest Stevens, the father of U.S. Supreme Court justice John Paul Stevens.

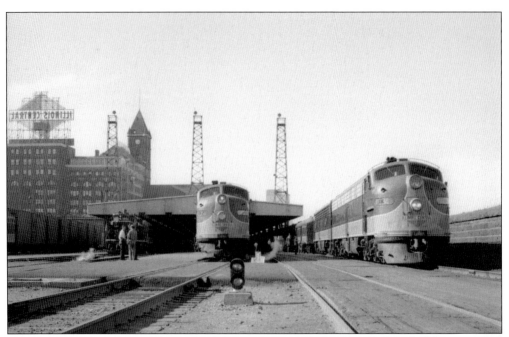

At 3:20 p.m. on June 21, 1960, three trains were photographed at the south end of the train shed waiting to depart. To the left is the *Land O' Corn*, scheduled to depart at 5:00 p.m. for Waterloo, Iowa. In the center is the *Panama Limited*, due out at 4:30 p.m. for its overnight sprint to New Orleans. Next is the *Seminole*, which will leave at 4:45 p.m. for Jacksonville, Florida.

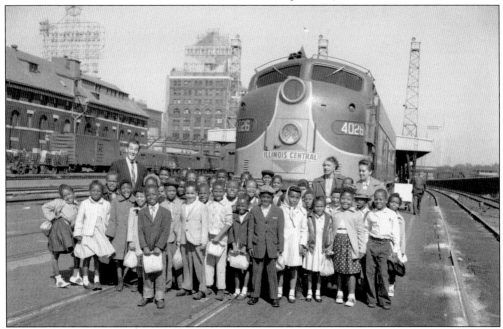

Taking a train ride once was a popular activity for school kids and youth groups. With their sack lunches in hand, a group of students pose in front of E8A 4026 around 1960. Illinois Central's Weldon Coach Yard, just south of Central Station, always had a supply of extra coaches available to handle unexpected traffic surges or to replace cars with mechanical problems.

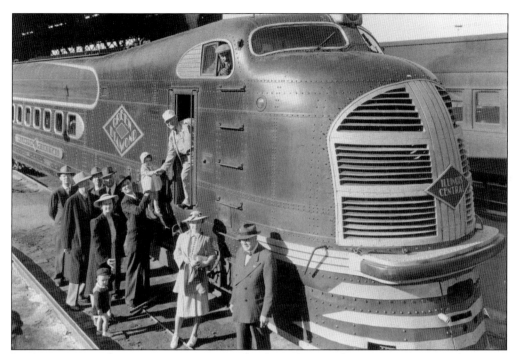

In 1941, a group of passengers pose next to the *Green Diamond*'s power car at Central Station. The *Green Diamond* made a round trip each day between St. Louis and Chicago. The train made its first run in 1936 and was the Illinois Central's first streamlined passenger train. With its bright two-tone green paint scheme and art deco styling, the train captured the public's attention. (Kaufmann and Fabry Company.)

Millions of famous, infamous, and not-so-famous people passed through Central Station over the years. On May 3, 1942, Mrs. Casey Jones, the widow of the legendary engineer, was photographed at Central Station standing between conductor E. E. Jolly (left) and engineer William Boedeke. The occasion was the first run of the streamlined version of the *Panama Limited*.

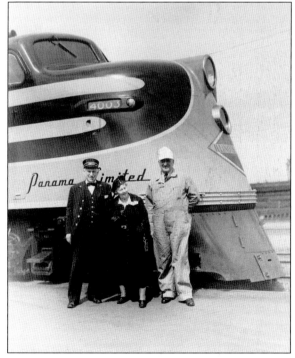

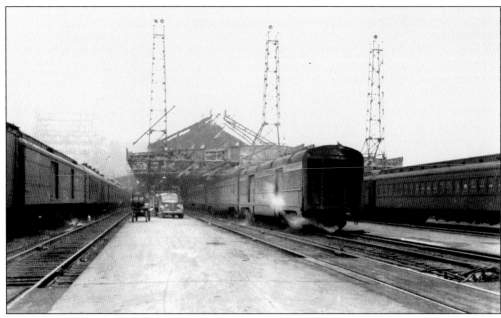

Over the years several modifications were made to Central Station. The most drastic was the 1944 rebuilding of the train shed. Many of the trusses at the top of the shed had corroded and weakened due to continuous exposure to steam locomotive exhaust. Illinois Central's engineers developed a plan to rebuild the shed without interrupting train operations. The supporting columns of the old shed were still in good condition, so these columns were used to support the new train shed. Prefabricated beams that formed a low roof were stitched into place within the skeleton of the old shed. The new shed had a much lower roof than the old shed. Once the new shed was complete, the top of the old shed was disassembled. The photograph above was taken during construction, and the photograph below shows the finished product.

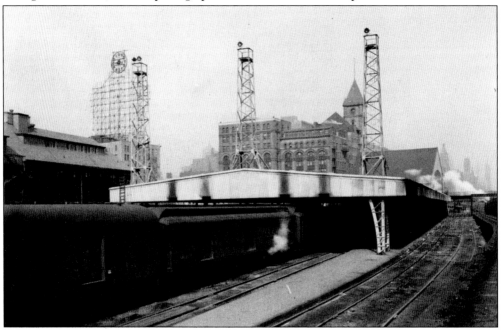

At the same time the train shed was rebuilt, the roof of the clock tower was rebuilt. During this project it was necessary to temporarily remove the clock faces so that scaffolding could be installed. Each clock face measured eight feet in diameter, while the minute hands were four feet long and the hour hands were 3.5 feet long. The clock mechanism was built by Seth Thomas.

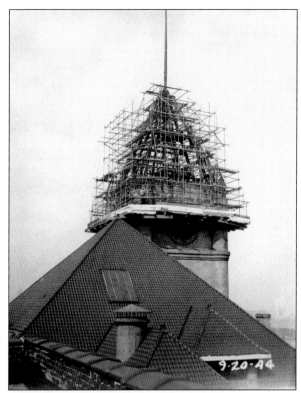

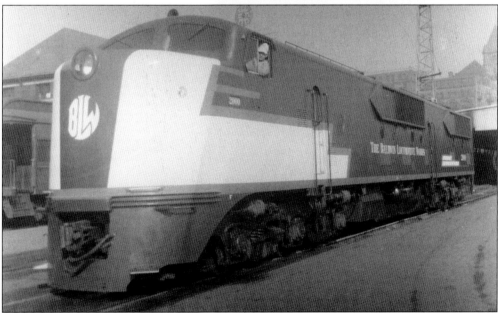

In early 1942, this prototype locomotive from the Baldwin Locomotive Works was briefly tested on the Illinois Central between Chicago and Birmingham. Inside the massive car body was a pair of eight-cylinder VO engines, each producing 1,000 horsepower. Following its road tests, the locomotive was displayed briefly at Central Station. Illinois Central wisely decided not to buy this troublesome beast, which eventually went to Mexico. (Clifford J. Downey collection.)

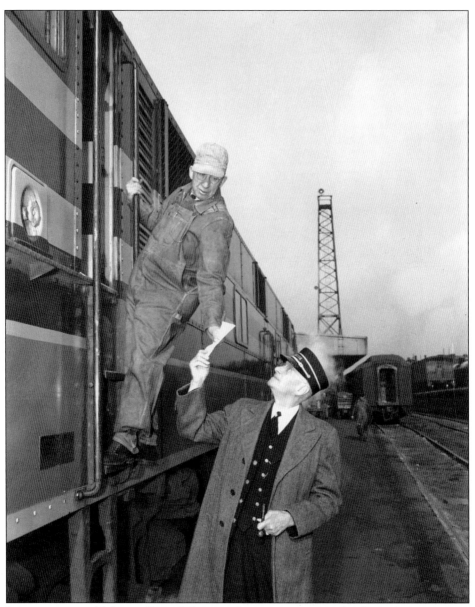

Before any train could depart Central Station, the crew was required to have the proper written train orders. These orders detailed meets with other trains, speed restrictions, and any special operating instructions the crew needed to be aware of. In this photograph taken around 1950, an engineer climbing into the cab of an E7A diesel-electric locomotive is receiving his orders from the conductor. Once the train is underway a dispatcher will issue new orders. These will be transmitted to a tower operator or station agent along the way, who will then write down the orders and deliver them to the train crew. Freight train crews also had to have train orders. Those crews received their orders in the freight yard when reporting to duty, and they too received updated orders along the way. Today most trains on major railroads are dispatched by Centralized Traffic Control (CTC). A dispatcher at a computer screen controls trackside signals, which in turn govern train movements. The dispatcher may be hundreds, or thousands, of miles from the train.

Three

PASSENGER SERVICE

The Illinois Central Railroad took great pride in its passenger service. The railroad's best-known train was the *Panama Limited*, running between Chicago and New Orleans. This all-Pullman train featured the finest amenities to be found on any railroad. Not only was it comfortable, but it was fast! Another notable train was the *City of New Orleans*, also running between Chicago and New Orleans. According to the railroad's October 25, 1959, timetable, both trains covered the 921 miles between Chicago and New Orleans in 16 hours, 30 minutes.

With a few exceptions, the Illinois Central operated over flat terrain devoid of steep hills. This allowed the railroad's passenger trains to really hustle. All of the railroad's E-unit locomotives were geared for a top speed of 117 miles per hour. If a passenger train should fall behind schedule, there was no doubt that the engineer would push his locomotives to the limit in an attempt to catch up.

The railroad spent a great deal of time and money to keep its passenger equipment in top condition. At Ninety-fifth Street the railroad had a large facility called the Burnside Shops devoted to the maintenance of its passenger and suburban equipment. The workers had the knowledge and tools necessary to rebuild or repair virtually any car. In the 1940s and 1950s, several old heavyweight cars were rebuilt at Burnside as sleek streamlined cars.

Over the years the Illinois Central spent millions of dollars on new passenger cars and locomotives. But as early as the 1920s passenger ridership began to decline. People were buying automobiles and began driving to their destination, rather than taking the train. As ridership fell, the railroad first began trimming passenger trains on lightly populated branch lines. But then the railroad was forced to cut Main Line trains.

On May 1, 1971, Amtrak took over the Illinois Central's remaining passenger service. Sadly, most trains were cut, including the famed *Panama Limited*. Yes, a train by that name was operated by Amtrak for several years, but it simply could not compare with the elegant service once enjoyed by passengers on the Illinois Central.

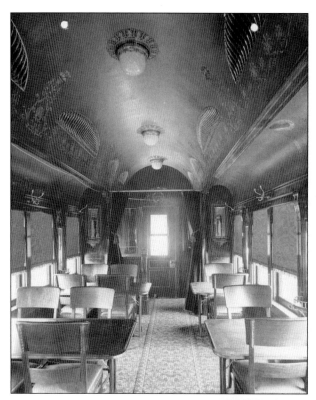

In the 1880s, George Pullman built a massive railroad car plant along Illinois Central's Main Line near 111th Street in south suburban Chicago. Pullman also established a company town next to the plant, named after himself, where his employees lived and shopped. The Illinois Central was a frequent Pullman customer, but the railroad also bought passenger cars from other companies. One of these was the Barney and Smith Car Company (B&S) of Dayton, Ohio. These two photographs show the interior of dining car 738, built by B&S around 1900. B&S was known for its high-quality cars, but by the early 1900s the company had run out of fresh ideas. In comparison, Pullman was continuously introducing new technology and designs. This allowed Pullman to became the dominant builder of railroad cars. (Clifford J. Downey collection.)

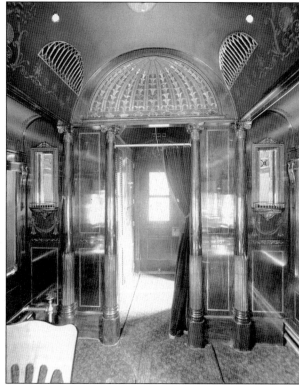

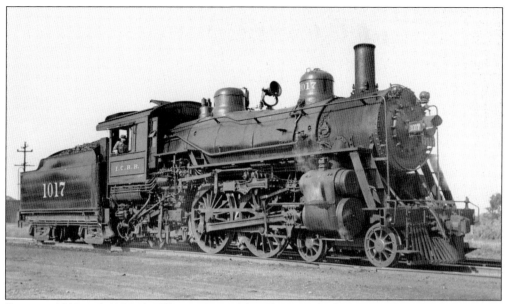

Between 1902 and 1904, the Illinois Central bought a total of 26 4-4-2s for passenger service. During their early years these locomotives were assigned to Illinois Central's Main Line trains and were common around Chicago. But the 4-4-2s lacked the power to pull heavy trains and were ultimately bumped onto secondary trains. No. 1017 was photographed around 1930. (Clifford J. Downey collection.)

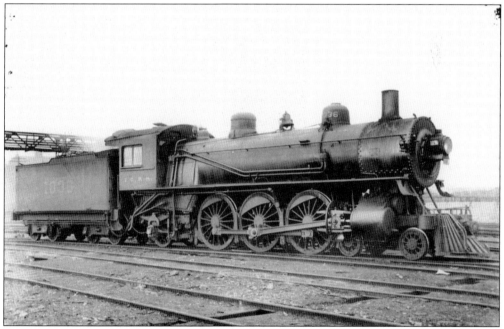

After experimenting with the 4-4-2, Illinois Central decided to go with the 4-6-2 Pacific type as the standard locomotive for its passenger trains. This locomotive type featured four pilot wheels under the front of the locomotive, six drivers, and two trailing wheels under the cab. No. 1036 was photographed near Central Station in late 1906, only a few weeks after construction. (John B. Allen collection.)

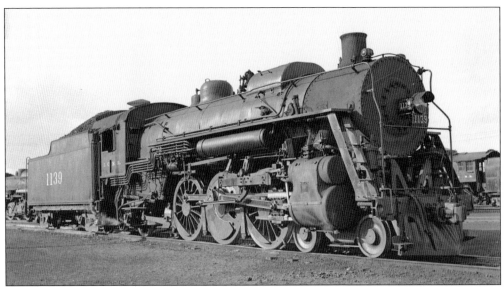

Between 1905 and 1920, the Illinois Central bought 173 new 4-6-2 Pacifics, numbered 1031–1203. During this time the 4-6-2 became the premier locomotive for Illinois Central's fastest and most important passenger trains. It would retain that title until the arrival of larger, more powerful 4-8-2s between 1923 and 1926. Locomotives 1139 and 1140 were both built by Alco in October 1916. No. 1139 was photographed in 1946 at Twenty-seventh Street and provides a look at the engineer's side of an Illinois Central 4-6-2. Sister 1140 provides a look at the fireman's side. This locomotive was photographed around 1948, also at Twenty-seventh Street. By this date these locomotives were hauling secondary trains, rather than the prestigious *Panama Limited*, but they still strike a commanding pose. No. 1139 was scrapped in 1952, while No. 1140 was scrapped in 1950. (Photographs by Charles T. Felstead.)

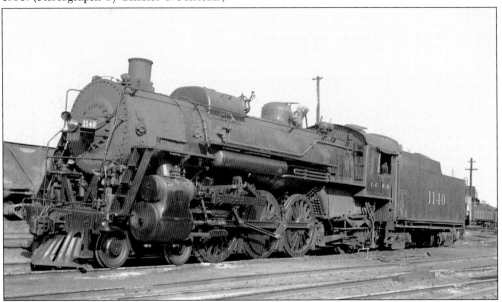

Staring at the camera is 4-6-2 1203. This locomotive was built in October 1920, and was the last 4-6-2 bought new by the Illinois Central (six secondhand 4-6-2s joined the roster in 1926 when the Illinois Central bought the Alabama and Vicksburg Railroad and the Vicksburg Shreveport and Pacific Railroad). No. 1203 was renumbered to 1138 in July 1937 and was scrapped in 1952. (Clifford J. Downey collection.)

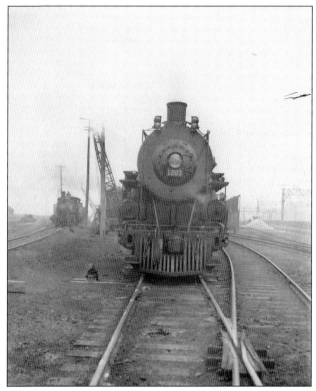

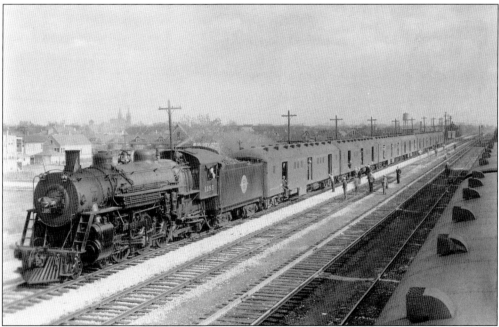

Not all passengers carried by the Illinois Central were human. The railroad carried numerous racehorses to various tracks scattered throughout the system. This special train with seven cars was photographed in the early 1930s near Homewood. These horses were destined for the nearby Washington Park Race Track at 175th Street and Halsted. (C. W. Witbeck collection.)

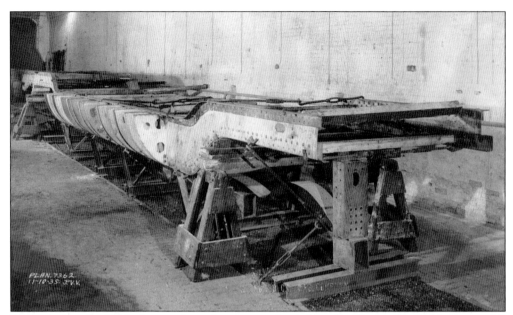

Beginning in the 1920s the number of passengers hauled by the Illinois Central began to fall steadily. Passengers were deserting trains and instead were driving to their destinations. To win back passengers, an order was placed with the Pullman-Standard Company on November 2, 1934, for a five-car streamliner to be used between Chicago and St. Louis. The train was to be powered by a diesel-electric motorcar. Inside this car was a 16-cylinder, 1,200-horsepower Model 201-A diesel engine built by the Electro-Motive Corporation (EMC). This engine was connected to an electrical generator. The electricity produced by this generator flowed to four traction motors mounted on the motorcar's four axles. These two photographs provide side and overhead views of the motorcar frame during construction. Once completed the motorcar will be 59 feet long. (Photographs by Pullman-Standard.)

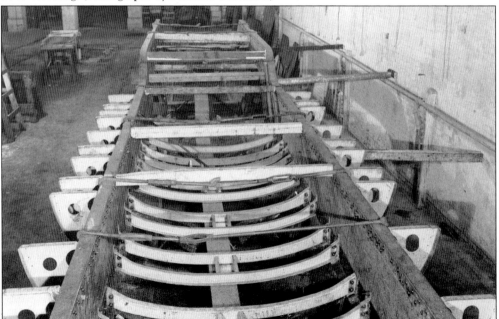

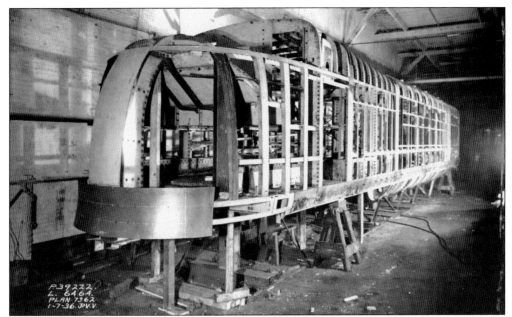

The car body of the *Green Diamond's* power car is taking shape in this photograph dated January 7, 1936. There were actually two diesel engines in the motorcar. The second engine was a six-cylinder, 100-horsepower engine connected to a generator used to charge batteries and generate electricity for the train's lights. The train was heated by a steam generator near the rear of the motorcar. (Photograph by Pullman-Standard.)

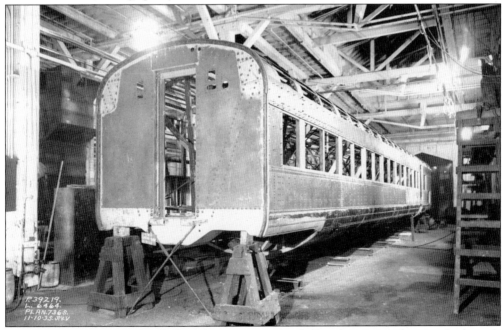

On November 10, 1935, the shell of the *Green Diamond's* fourth car was photographed inside Pullman-Standard's plant in Pullman. This car had a 44-seat coach section at the front of the car, which is the end closest to the camera. At the rear of the car was a 16-seat dining section. The five cars were articulated with the car next to it. (Photograph by Pullman-Standard.)

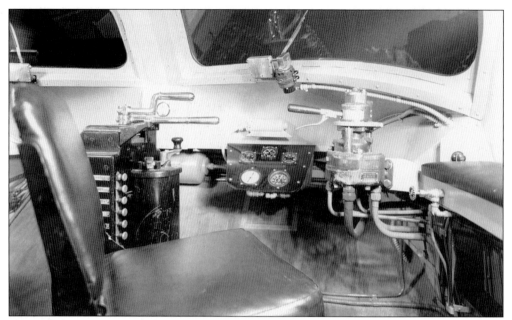

As viewed from the inside looking out, the windshields of the *Green Diamond*'s motorcar resembled a strange angry bug from another planet. In front of the engineer's seat was a control stand with two brake handles. In the center is a panel with a speedometer and air-pressure gauges. The throttle, with its silver handle resembling a bicycle brake, is on the right.

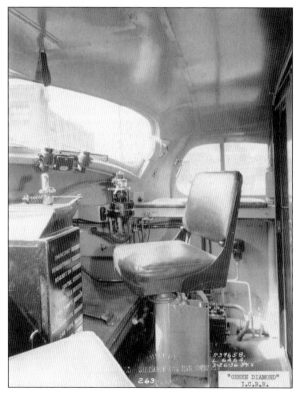

The cab of the *Green Diamond*'s motorcar was very Spartan. As this view of the engineer's seat shows, the crew did not enjoy the comforts and amenities provided in the rest of the train. The cab was heated but it did not have air conditioning. Directly behind the engineer's seat was a door leading to the engine compartment. (Photograph by Pullman-Standard.)

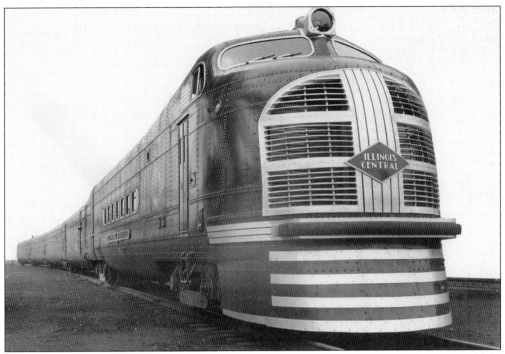

This heavily retouched photograph of the *Green Diamond* was taken at Pullman-Standard's plant. On March 27, 1936, the Illinois Central formally took delivery of the train at St. Louis. After a few break-in runs, the train went on a month-and-half publicity tour that went as far as Dallas, Texas. Then on May 17, 1936, the train entered regular service between Chicago and St. Louis. (Photograph by Victor T. Fintak Studios.)

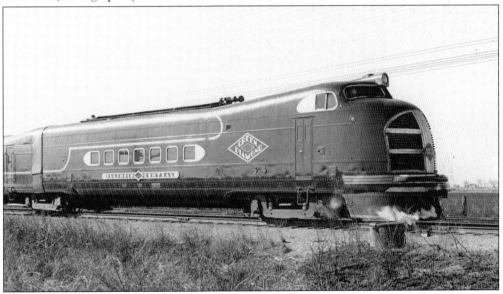

The five cars of the *Green Diamond* were painted dark green on the lower part of the car bodies and light green on the upper part. Silver and scarlet stripes separated the two bands. The paint scheme, and the train's name, were selected because green diamonds are very rare, and the railroad wanted the public to view its new train as a rare gem. (M. D. McCarter collection.)

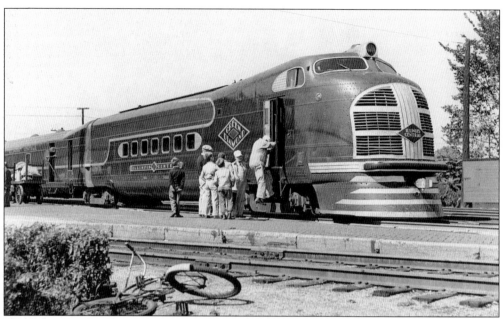

The *Green Diamond* seemed to attract everyone's attention. During a station stop at Clinton on September 25, 1937, a group of boys have abandoned their bicycles to inspect the motorcar. One of the crew members is climbing into the engine compartment, which leads into the cab. The five cars of the *Green Diamond* were numbered 121 through 125, beginning with the power car. (Clifford J. Downey collection.)

The second car of the *Green Diamond*, No. 122, was divided between a baggage compartment and a railway post office (RPO). The photographer is standing in the baggage compartment, and the RPO is behind the wall in the background. In the middle of the wall, at floor level, is a small door that the mail clerks had to crawl through to enter the RPO compartment. (Photograph by Pullman-Standard.)

The interior of the *Green Diamond* was decorated in the art deco style that was wildly popular in the 1930s. This photograph was taken in the last car of the train, a combination diner-lounge. The view is looking toward the rounded observation end. The rear door opens, but was used only in an emergency. Outside the door was an illuminated sign with the train's name. (Photograph by Pullman-Standard.)

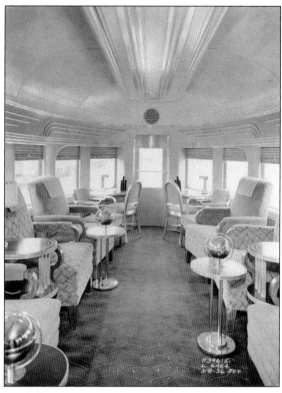

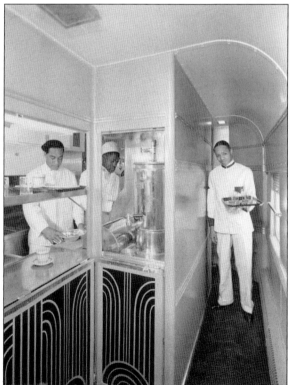

This publicity photograph of the *Green Diamond's* kitchen was taken before the train entered service. The kitchen was located in the fifth, or rear, car of the train. There were two dining tables in this car, plus four more dining tables in the fourth car. The coach seats were also equipped with fold-down tables on the seat in front of them, much like today's airliners. (Photograph by Pullman-Standard.)

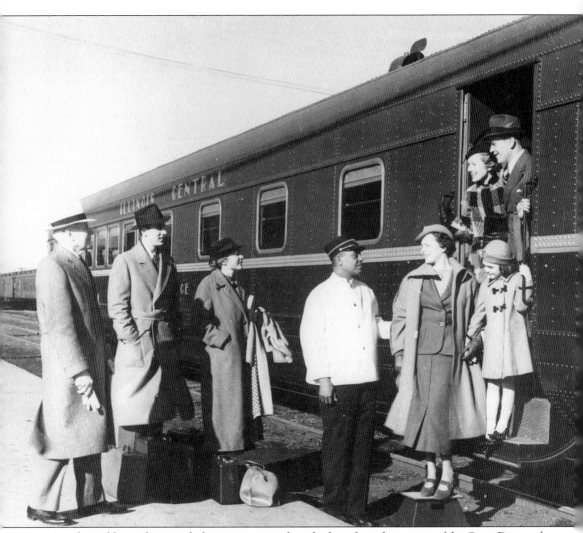

Another publicity photograph shows passengers disembarking from the rear car of the *Green Diamond*. The train's skin was covered with a newly developed steel alloy called Cor-Ten, which was much lighter than steel traditionally used in passenger car construction. Unfortunately, Pullman-Standard had not yet developed a method of welding this steel, so rivets had to be used. This blemished the train's graceful lines. Despite this slight imperfection the train was very successful in winning back passengers, just as the railroad's management hoped it would. In fact, business grew to the point that more seating was needed. That was impossible to do, since the *Green Diamond* was articulated and more cars could not be added. So in late 1946, conventional cars and locomotives were assigned to the *Green Diamond*. The old train was reassigned to the *Daylight*, another Chicago-St. Louis train. Then on April 27, 1947, the train began operating as the *Miss-Lou* between New Orleans and Jackson, Mississippi. In 1950, the train was withdrawn from service and sent back to Chicago, where it was scrapped at the Burnside Shops. (Photograph by Pullman-Standard.)

Illinois Central's second streamlined passenger train was the *City of Miami*, operating between Chicago and Miami, Florida. This seven-car all-coach train entered service on December 18, 1940. The train was initially pulled by E6A 4000, photographed before delivery. The diamond on the nose was scarlet, with a palm green outline and "Illinois Central" lettering. On the nose was a palm green wave with three orange stripes. At the rear of the locomotive, the roof was also painted palm green. The cab and sides of the locomotive were painted orange. No. 4000 was the only locomotive painted in this scheme, for in 1942 the Illinois Central adopted chocolate brown and orange as the standard colors for its streamline fleet. Around 1946, the *City of Miami* train set was repainted chocolate brown and orange. (EMD General Motors.)

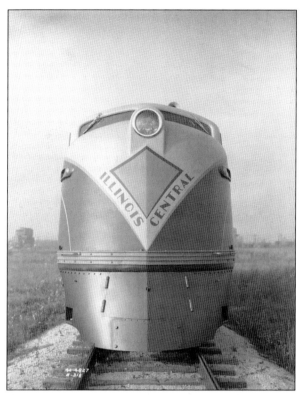

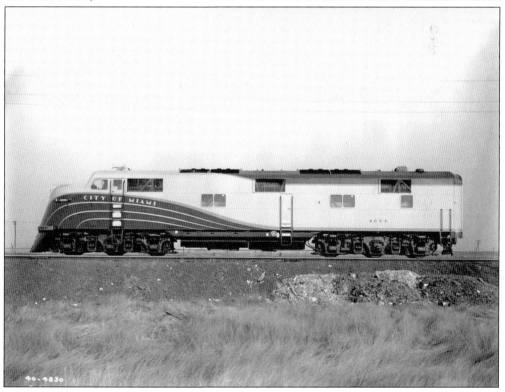

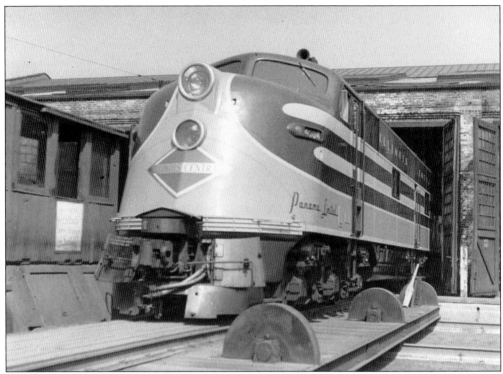

In late 1941, the Illinois Central began making plans to install streamlined cars and locomotives on the *Panama Limited*, the road's most prestigious passenger train. Two train sets were assembled, and each train set required two locomotives to pull it. Four E6A's, numbered 4001–4004, were purchased from the EMD. No. 4004 was photographed at Burnside Shops in early 1942. (Clifford J. Downey collection.)

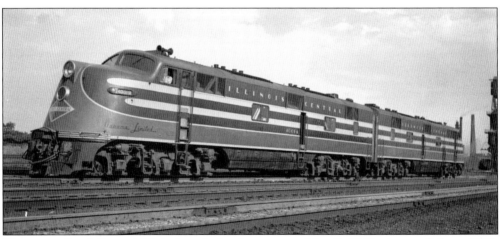

The streamlined *Panama Limited* made its first run on May 3, 1942. A month later E6A's 4001–4004 were renumbered 4001-A, 4001-B, 4002-A, and 4002-B, respectively. Soon afterward 4001-A and 4001-B were photographed at Twenty-seventh Street. In 1946, the locomotives regained their original numbers. The *Panama Limited* lettering disappeared in 1946 when new locomotives for the *Panama* arrived and the older E6A's began appearing on other trains. (Clifford J. Downey collection.)

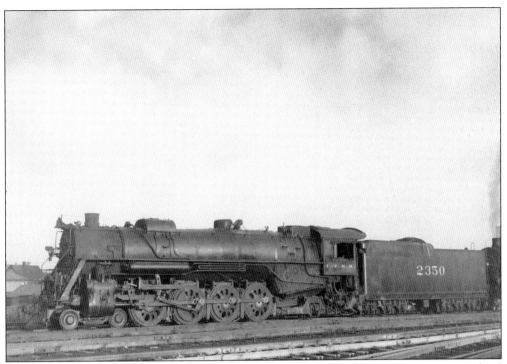

As traffic soared during World War II, the Illinois Central needed additional locomotives to haul its passenger trains. Buying new locomotives was not possible, so in 1944 and 1945, 11 2400-class 4-8-2s were rebuilt at Paducah with new boilers. These locomotives were renumbered 2300–2307 and 2350–2352. No. 2350, photographed around 1950, received one of the big 12-wheel tenders formerly assigned to a 7000-class 2-8-4. (Clifford J. Downey collection.)

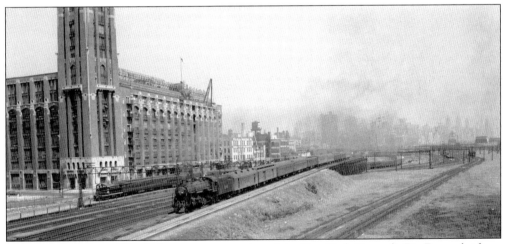

Between Chicago and Kankakee, passenger trains of the New York Central's Big Four subsidiary traveled over Illinois Central tracks. While on the Illinois Central, these trains were operated by Illinois Central crews and were typically (but not always) pulled by Illinois Central locomotives. In this undated photograph a southbound Big Four passenger train storms past Twenty-third Street on the Main Line. On the point is 4-6-2 1186. (Clifford J. Downey collection.)

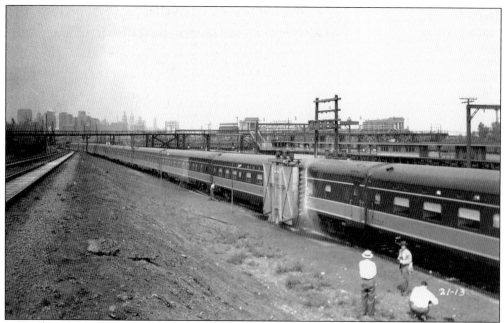

The Illinois Central and its employees took great pride in operating passenger trains that were clean and comfortable. After a passenger train arrived at Central Station the locomotives were sent to the Twenty-seventh Street roundhouse for servicing. Next the passenger cars were whisked away to the Weldon coach yard, just south of Central Station. Workers swarmed through the train, cleaning the bathrooms and kitchens, washing windows, replacing headrests and linen, and performing countless other housekeeping tasks. Once the train was clean on the inside it went through a wash rack where a cleaning solution was sprayed on each car. Brushes then scrubbed away dirt and grime, which was rinsed away with high-pressure water jets. In these two 1946 photographs the *Panama Limited* was going through the wash rack. (Whiting Corporation.)

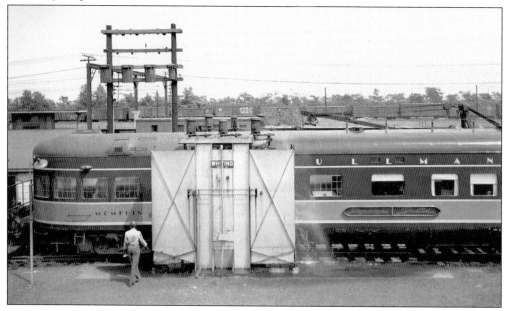

The railroad's commitment to cleanliness extended to the locomotives pulling its passenger trains. The admonition "Don't Spit On Floor" was stenciled on the sun visors in the cab of each Illinois Central E-unit. In this photograph taken around 1955 the engineer has his left hand on the air horn cord and his eyes focused on the tracks ahead. (Clifford J. Downey collection.)

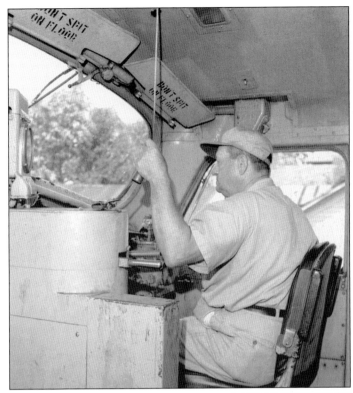

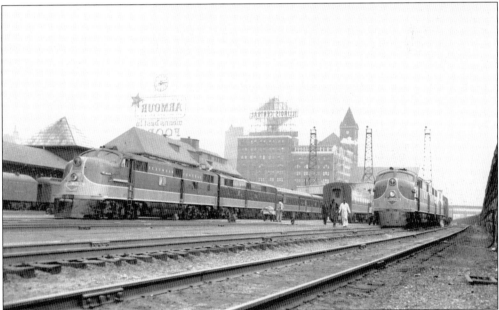

Three different streamliners are visible in this photograph taken in 1953 at Central Station. The two trains at left and right are ready for departure, while in the middle is a third train that has just arrived. Before any train can depart, car inspectors thoroughly check each car to ensure the brakes are working correctly, all cables and hoses are secure, and there are no mechanical or electrical problems.

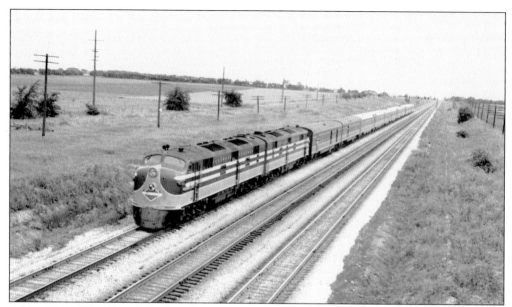

After World War II ended, the Illinois Central began making plans for a new streamliner between Chicago and New Orleans. This all-coach train would operate during the daytime, complimenting the overnight *Panama Limited*. Known as the *City of New Orleans*, the train would eventually be immortalized in song by Arlo Guthrie and Willie Nelson. The train was worthy of recognition, for it was fast and comfortable. The 921-mile run between Chicago and New Orleans was made in 15 hours, 55 minutes. New coaches were bought from Pullman-Standard, while Illinois Central's Burnside Shops constructed diners, observation cars, mail cars, and baggage-dormitory cars from older heavyweight cars. The *City of New Orleans* made its first run on April 27, 1947. A few months later the train was photographed traveling southbound near Kankakee. On the rear is observation car *Mardi Gras*.

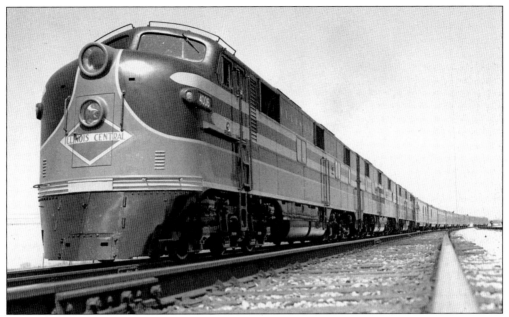

This publicity photograph of the *City of New Orleans* was taken shortly before the train entered service. The train left Chicago each morning with 11 cars. At Carbondale the train picked up a coach from St. Louis. Then at Fulton, Kentucky, the train picked up two coaches from Louisville, Kentucky. These cars ran through to New Orleans. On the northbound trip the process was reversed.

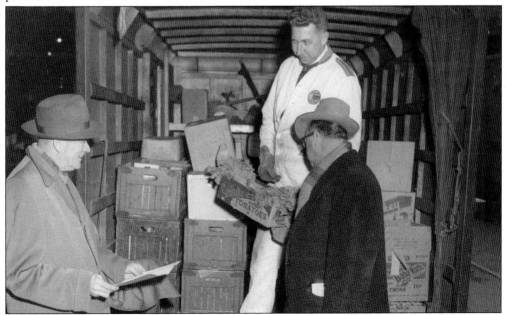

Food destined for Illinois Central's dining cars is being inspected in this photograph taken around 1960. Dining aboard a train has always had a hint of nostalgia and intrigue, but like most railroads, the Illinois Central's dining cars operated at a loss. In 1957, the Illinois Central lost $868,863 on its dining car operations. The deficit was trimmed to $577,004 by 1960, mainly by downgrading service on secondary trains.

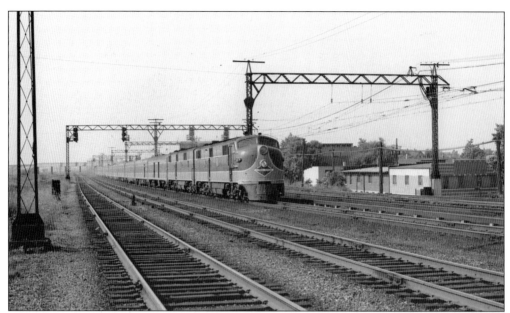

An E7A and E7B are on the point as the northbound *Panama Limited* rolls through Kensington (115th Street) early one morning in mid-1950 (above). The train is on the last leg of its overnight 921-mile dash from New Orleans. Later that same morning the southbound *City of Miami* was photographed at Kensington (below). Pulling the train are two new E8As bracketing an older E7B. When the *City of Miami* made its first run in December 1940, the train was all-coach. This would have been most uncomfortable for passengers traveling all the way between Chicago and Miami, for the trip covered 1,439 miles and took 32 hours. This was the longest run of any passenger train ever operated by the Illinois Central. On April 23, 1949, sleepers were added to the train. (M. D. McCarter collection.)

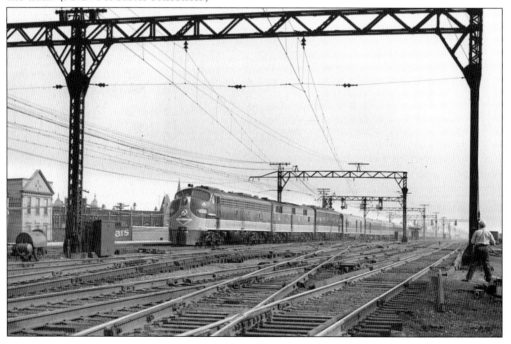

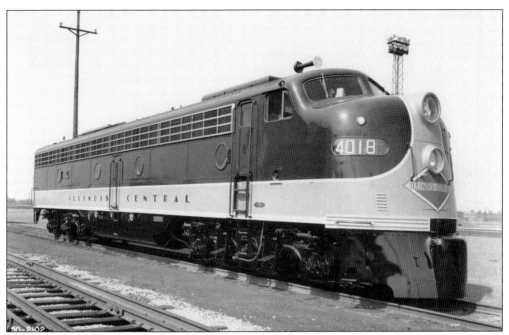

E8A 4018–4021 were built in June 1950. No. 4018 is seen in this builder's photograph taken before the locomotive was delivered. Note the diamond emblem on the nose underneath the headlights. Later locomotives had a diamond emblem with sidebars, and this new emblem was applied to older units when they were repainted. (EMD General Motors.)

A scarred and battered E8A 4021 rests at the Twenty-seventh Street roundhouse in this undated photograph. Illinois Central's passenger locomotives received routine paint touch-ups and usually were completely repainted every three to four years. Unfortunately, after a change of management in the late 1960s, many Illinois Central locomotives began taking on a shabby appearance. (Clifford J. Downey collection.)

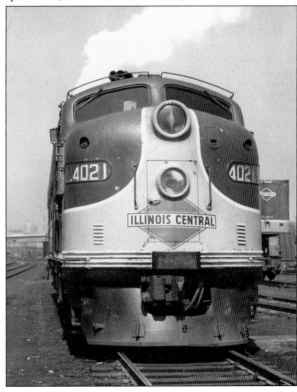

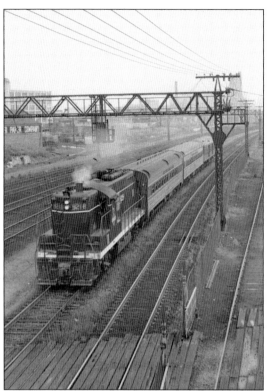

On July 4, 1966, the southbound *Sycamore* rolls past the Twenty-seventh Street shops behind GP9 9218. The *Sycamore* was not an Illinois Central train. Instead it was a Chicago to Indianapolis train operated by the Cleveland, Cincinnati, Chicago and St. Louis Railway, better known as the Big Four. Between Chicago and Kankakee, Big Four passenger trains operated over Illinois Central trackage. (Photograph by Louis A. Marre.)

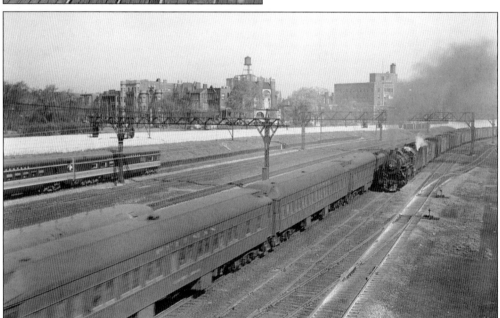

Four trains are visible in this photograph taken around 1950 near Thirty-fifth Street on the Main Line. A southbound freight train behind 2-8-2 1478 is headed toward the camera on the right. To the left is a northbound passenger train with heavyweight Pullmans. This train obscures the streamlined observation car on the southbound *City of Miami*. At far left is the southbound *City of New Orleans*. (Kaufmann and Fabry Company.)

Four

SUBURBAN SERVICE

Illinois Central's suburban service dates back to the 1850s. When the railroad began building tracks from Lake Calumet (later renamed Kensington) north toward Chicago, the railroad needed a strip of land owned by Paul Cornell, a land developer. Cornell agreed to sell the land, but with a few conditions. The railroad had to build a station on the land called Hyde Park, and the railroad had to offer daily passenger service between downtown Chicago and Hyde Park.

This new passenger service was inaugurated on June 1, 1856, when numerous dignitaries rode from Great Central Station in Chicago to Hyde Park. However, regularly scheduled service did not begin until July 21, 1856. Legend has it that not a single passenger rode the July 21 trip.

The early years were rough, and in 1857, plans were made to drop the service because the railroad was losing so much money. Cornell then stepped in and offered to cover some of the losses out of his own pocket. This subsidy persuaded the Illinois Central to stay in the suburban business. Illinois Central thus became the first railroad west of Philadelphia to offer commuter train service. But from the start, the railroad used the term "suburban service."

From its humble start the suburban service grew rapidly. By 1890 the railroad was operating 114 suburban trains daily and was carrying four million passengers yearly. In 1921, the railroad carried nearly 20 million suburban passengers and raked in $2.2 million from the service.

A tremendous amount of smoke was generated by the locomotives pulling the Illinois Central's suburban, passenger, and freight trains. City leaders, ever mindful of their city's image, passed the 1919 Lake Front Ordinance mandating the Illinois Central electrify its suburban trains by 1927. This task was complete in 1926 at a cost of over $16 million.

The electrified suburban train service was a source of great pride to the Illinois Central. Today the service is operated by METRA, but it is still among the finest commuter train operations to be found on any Chicago railroad.

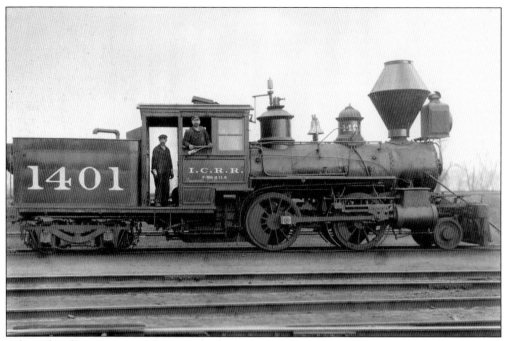

When the Illinois Central began suburban service, the railroad used whatever locomotives were available at train time. Some of these locomotives were not suited to the service, so the railroad began buying locomotives designed specifically for suburban service. The first of these locomotives was 2-4-4T 213, built by Rogers in May 1880. This locomotive was photographed around 1920 after it had been renumbered to 1401. (Clifford J. Downey collection.)

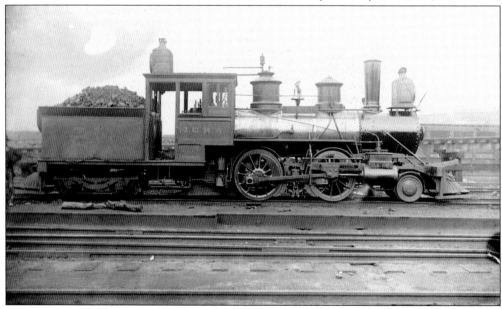

Seven more 2-4-4Ts were purchased from Rogers between 1881 and 1883. Using these locomotives as a pattern, the Illinois Central built 13 more 2-4-4Ts in its own shops between 1885 and 1891. This broadside photograph of homebuilt 211 was taken around 1895. With a fully loaded tender this locomotive weighed just over 117,000 pounds. (Clifford J. Downey collection.)

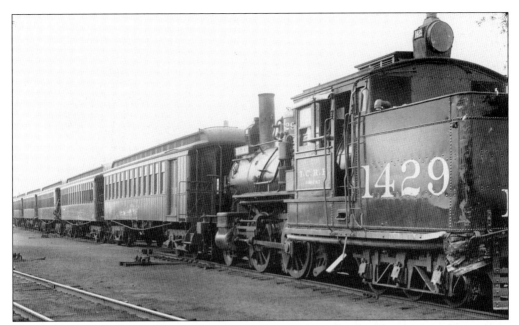

Illinois Central's early suburban trains were built not for comfort but for transporting as many passengers as possible in a single trip. This six-car train was photographed around 1910 at an unidentified station. The first car has a small baggage compartment for the storage of newspapers. Suburban trains on the Illinois Central and other Chicago railroads were commonly used to transport newspapers from downtown printers to the suburbs.

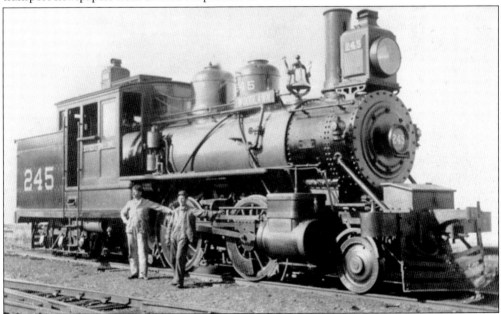

A variety of steam locomotives were used in suburban service. The 2-4-6T 245 was built by Rogers in April 1893. That small tender mounted on the rear deck held just 2,500 gallons of water and six tons of coal. In 1900, this locomotive was renumbered 1428. After the suburban service was electrified in 1926, No. 1428 was used to switch freight yards before its 1935 retirement. (Clifford J. Downey collection.)

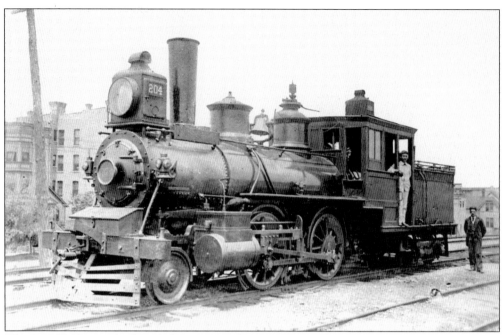

The 2-4-4T 204 was built in February 1883 by Rogers. This locomotive was photographed in 1895 with its original oil-burning headlight. In a few years a smaller electric headlight will be installed. As with all locomotives used in suburban service, it was designed to accelerate and stop quickly. (Clifford J. Downey collection.)

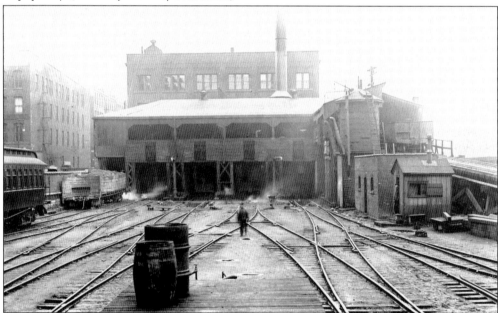

Locomotives used in suburban service refilled their tenders at this wooden chute near the Randolph Street Station. Coal was stored in overhead bins, and water was delivered from spouts connected to wooden water towers. This photograph was taken in December 1914. Smoke from Illinois Central steam locomotives operating downtown prompted the City of Chicago to pass the Lakefront Ordinance of 1919, requiring the railroad to electrify its downtown trackage.

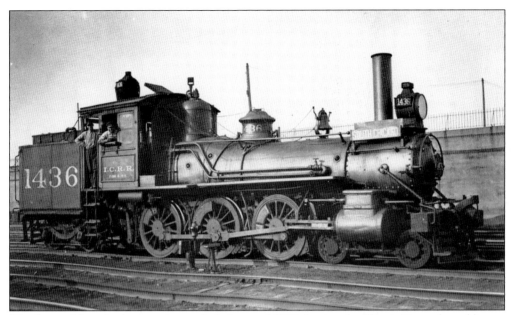

The demand for suburban service exploded around 1900, forcing the Illinois Central to add more equipment. No. 1436 is one of seven 4-6-0 ten-wheelers rebuilt as 4-6-4Ts between 1901 and 1904. All seven locomotives were originally owned by the Chesapeake Ohio and Southwestern Railway (CO&SW), running from Louisville, Kentucky, south through Paducah and Fulton, and onward to Memphis. Illinois Central took over the CO&SW in 1896. (John Allen collection.)

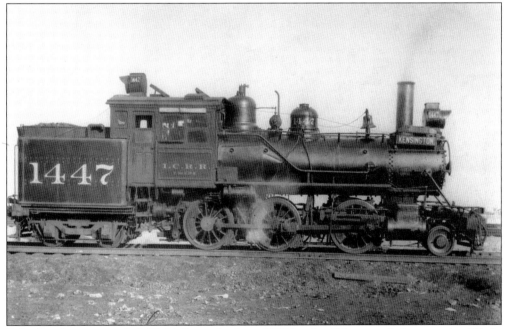

Suburban locomotive 2-6-4T 1447 was built in 1889 by the Schenectady Locomotive Works as a conventional 2-6-0. Originally numbered 448, it was rebuilt in 1921 at Illinois Central's Burnside Shops as a 2-6-4T. The old tender was replaced with a stubby tender that held 2,750 gallons of water and 5.5 tons of coal. (Clifford J. Downey collection.)

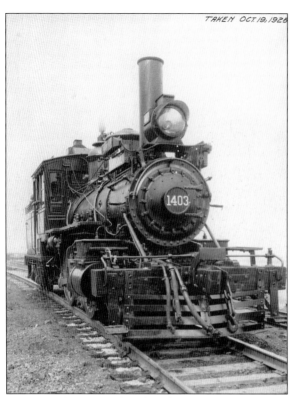

These two photographs illustrate the front (left) and rear end (below) of suburban locomotive 2-4-4T 1403. The large funnel-shaped pipe on the rear was the water fill pipe. The wide mouth was intended to help speed up the process of taking on water. And, with the pipe on the outside of the locomotive, it was possible to load a few more gallons of water. This was important since the tender held just 1,950 gallons of water, which was barely enough for a round trip from downtown Chicago to Matteson. After Illinois Central electrified its suburban service in 1926 many of the steam locomotives formerly used in this service were reassigned to yard service. No. 1403 was sold for scrap in 1928, over 43 years after it was built. (Clifford J. Downey collection.)

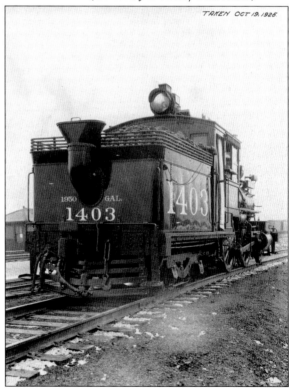

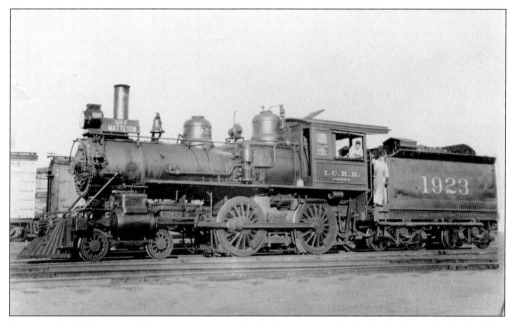

During the 1920s, several locomotives were drafted into suburban service but not rebuilt. One of these locomotives was 4-4-0 1923, photographed at Matteson in 1922. A signboard was added next to the smokestack on each side of the locomotive, but otherwise the locomotive was not modified. By this date crews were busy stringing wires for the electrification of Illinois Central's suburban service. (Clifford J. Downey collection.)

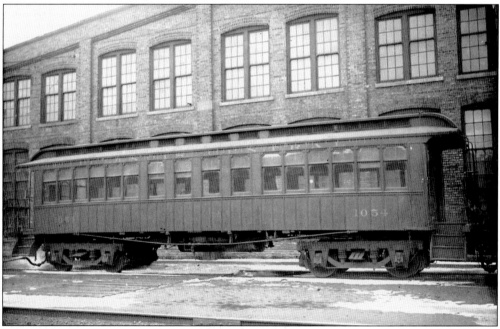

Wooden coach 1054 is typical of the cars used in suburban service from the late 1800s to 1926, when the service was electrified. The car was steam heated, had gaslights, and no restrooms. The windows could be raised during the summertime in hopes of catching a cool breeze coming off Lake Michigan. But opening the windows also allowed cinders to enter the car.

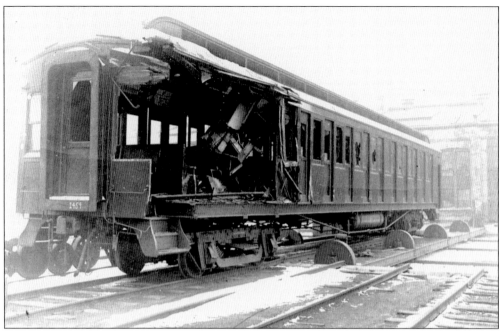

Illinois Central's suburban service had a very good safety record, but accidents did happen. Witness suburban car 1459 after a collision around 1900. Part of the wooden car has been peeled away, revealing the seats. Fortunately, the car had a steel under frame or the damage undoubtedly would have been much worse. (Clifford J. Downey collection.)

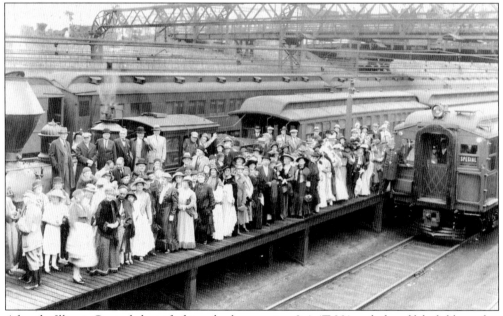

After the Illinois Central electrified its suburban service, 2-4-4T 201 and a handful of old wooden cars were kept by the railroad for use during special occasions. One of these was the 1933–1934 world's fair, held to celebrate the city's centennial. Passengers dressed in clothing from the 1800s pose near Soldier Field with the old suburban equipment behind them, and a new suburban car at right.

Five

FREIGHT SERVICE

Chicago was a major source of freight traffic for the Illinois Central. Approximately 25 percent of all freight revenue on the railroad was generated in Chicago, and in 1936, nearly two million freight cars were handled by the Illinois Central in Chicago. To handle this traffic the railroad had freight yards scattered through the city.

The largest freight yard was Markham Yard, near Homewood. Completed in 1926 at a cost of over $12 million, the yard had 114 miles of track and could hold 9,000 cars. Other major freight yards included Fordham (Eighty-seventh Street), Thirty-first Street, Wildwood Yard, Congress Street, South Water Street, and Hawthorne (Cicero).

Illinois Central's passenger and suburban train operations tended to get the most attention from the public. However, most revenue was generated by its freight service. In 1951, the Illinois Central generated $23.3 million in passenger revenue. That same year the railroad's freight trains generated $243.1 million.

Until the 1960s a considerable amount of business was generated by the freight houses at South Water Street. These freight houses specialized in less-than-carload business. Shippers that did not have enough freight to fill an entire car could ship their cargo in a freight car along with freight from other small shippers. This business accounted for only a small percent of Illinois Central's freight business, but since shippers paid a premium for the service, it was very profitable.

Illinois Central's freight business experienced several changes during the 1950s and 1960s. One of these was the near total collapse of the less-than-carload freight business. At the same time, the railroad's "trailer on flat car" service, or TOFC, grew considerably. Trailers that normally would be hauled long distances by trucks were instead loaded onto railroad flatcars for most of their journey. Then they would be unloaded and delivered to their final destination by rail.

Over the years the Illinois Central developed a diverse freight business. This helped considerably as factories in the Midwest began to close in the 1970s and production shifted overseas. During this time period several other railroads operating out of Chicago went bankrupt.

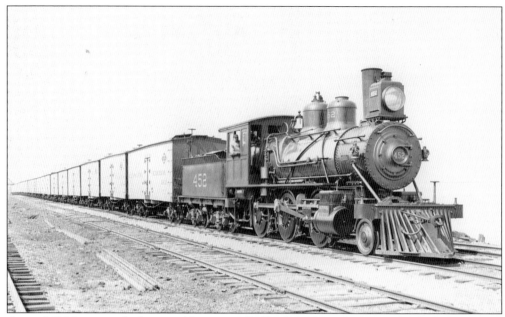

Around 1900 a train of refrigerated boxcars pulled by 2-6-0 Mogul 452 pose for their photograph along the Chicago lakefront. The Illinois Central was one of the first railroads in Chicago to use refrigerated cars for the transportation of fruits, vegetables, and dressed meat. The railroad's efforts made it possible to ship bananas and tropical fruit from docks along the Gulf Coast to Chicago.

The Chicago Produce Terminal at Twenty-seventh Street and Ashland Avenue served as the centralized auction house and unloading point for all carloads of fruits and vegetables shipped to Chicago. Opened in 1925 at a cost of $12 million, the facility was co-owned by the Illinois Central and the Santa Fe Railway, but all railroads serving Chicago had access. This photograph taken around 1930 shows some of the unloading tracks.

Illinois Central's main Chicago freight house was located along South Water Street. One of the loading docks is seen in this photograph taken around 1915. Railroads were not the only transportation source facing competition from trucks in the early 1900s. Trucks have the horse-drawn wagons outnumbered, eight to six. (Clifford J. Downey collection.)

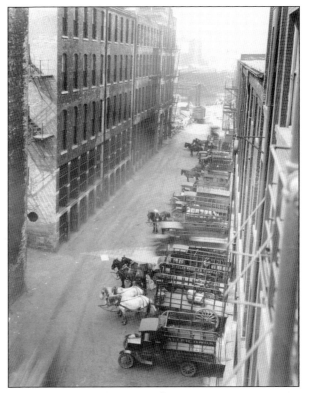

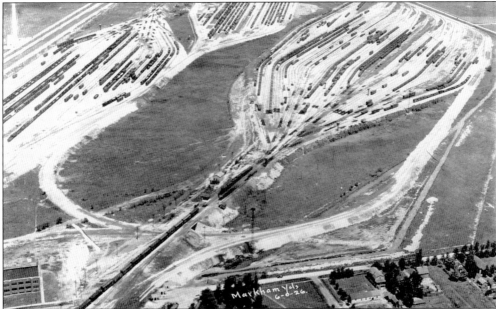

During the early 1900s, Illinois Central's freight traffic through Chicago increased dramatically. In response the railroad planned a new freight yard of immense proportions along the Main Line between Harvey and Hazel Crest. The new yard occupied more than 600 acres of land, had approximately 115 miles of trackage, and could hold 9,000 freight cars. The yard opened in 1926 and was named for Illinois Central president Charles Markham.

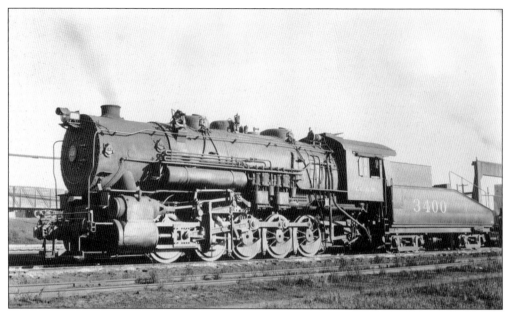

Markham Yard was a magnet for unusual locomotives. Two such locomotives were 0-10-0's 3400 and 3401, built for the Alabama and Vicksburg Railway (A&V). These locomotives were originally assigned to the A&V's Mississippi River ferry at Vicksburg, Mississippi. In 1926, the Illinois Central took over the A&V. Then in 1929, the Vicksburg ferry was replaced by a new bridge. This made the 0-10-0s surplus and they were transferred to Markham.

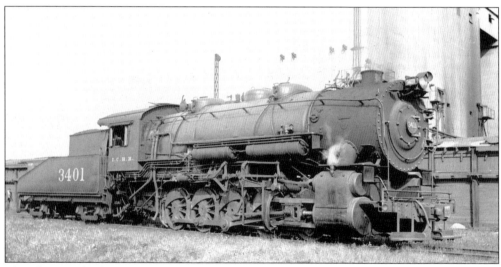

The photograph above shows the fireman's side of 0-10-0 3400, while this photograph shows the engineer's side of sister 3401. These locomotives were built to burn oil. In July 1934, both locomotives were rebuilt to burn coal. The tender could hold 14 tons of coal and 7,000 gallons of water. With a fully loaded tender these two locomotives weighed 468,300 pounds. (Charles T. Felstead collection.)

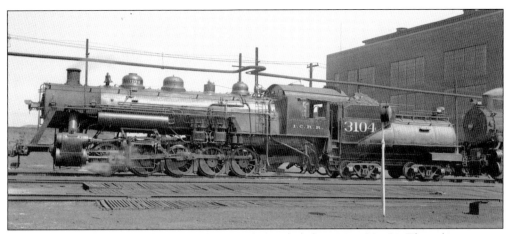

The Alabama and Vicksburg Railroad roster also included 2-10-2s 470-474. These locomotives were initially renumbered IC 3100–3104. All five locomotives were rebuilt at Illinois Central's Paducah, Kentucky, shops as 0-10-0s by removing the pilot and trailing trucks. This broadside photograph of 3104 taken on May 23, 1937, at Markham Yard shows the empty space formerly occupied by the pilot truck. Later this locomotive was renumbered 3606. (Charles T. Felstead collection.)

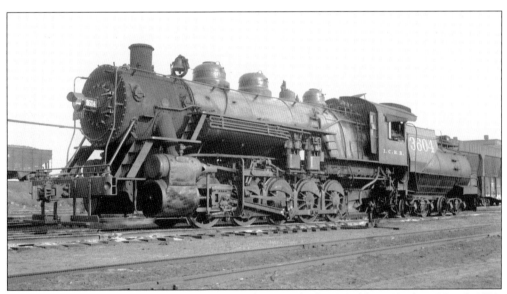

Another of the rebuilt 0-10-0s was No. 3604, photographed at Markham Yard on May 5, 1939. The rebuilt 0-10-0s had Vanderbilt tenders, a rarity on the Illinois Central. These tenders had a cylindrical water tank, rather than the traditional rectangular box. This type of tender was invented by Cornelius Vanderbilt, the great-grandson of railroad baron Commodore Vanderbilt. (Photograph by Charles T. Felstead.)

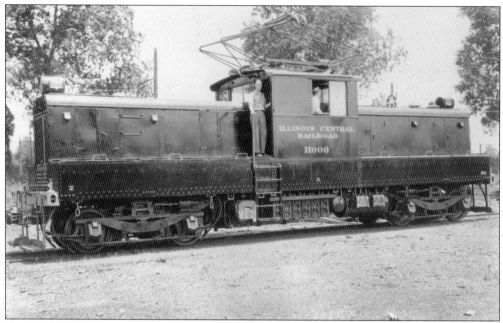

To comply with the 1919 Lake Front Ordinance requiring electrification of its Chicago freight yards, the Illinois Central experimented with several different types of locomotives. In 1929, the railroad tested three "tri-power" locomotives from the St. Louis Car Company. Locomotives 11000–110002 could draw electricity from overhead wires, generate electricity using a Buda diesel engine/generator set, or use electricity stored in batteries. These locomotives were not successful and were soon returned. Also in 1929, electric locomotives 10000–10003 were purchased from Baldwin-Westinghouse. These locomotives could only draw electricity from overhead wires. No. 10003 was photographed at Randolph Street on May 26, 1940. The city of Chicago decided in 1941 that diesel-electric locomotives, and not just electric locomotives, were suitable replacements for steam locomotives. Locomotives 10000–10003 were soon sold, and the overhead wires in the freight yards were taken down. (Clifford J. Downey collection.)

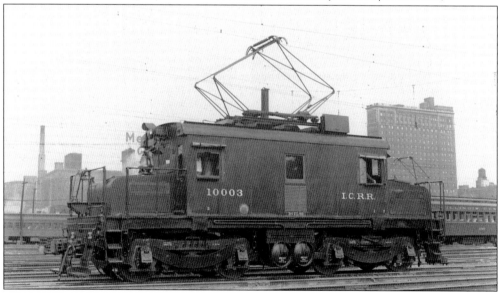

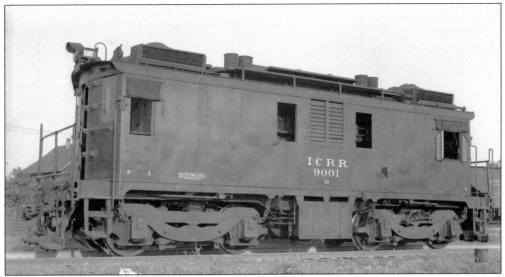

During the 1930s, the Illinois Central bought several diesel-electric locomotives as replacements for steam locomotives in downtown Chicago. Locomotives 9000–9005 were built in 1929 and 1930 and were known as "boxcabs" for their appearance. No. 9001 was photographed at Markham Yard around 1935. (Clifford J. Downey collection.)

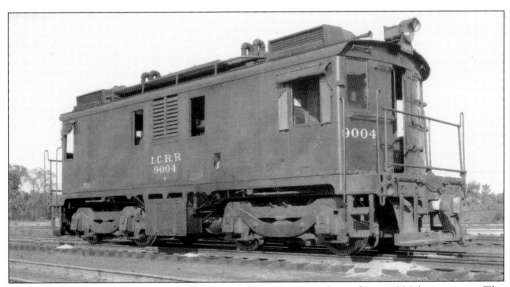

"Boxcabs" 9000–9005 had a pair of six cylinder engines, each producing 300 horsepower. The engines were built by Ingersoll-Rand, while the car body and electrical gear were built by General Electric. In 1950, all six locomotives were retired. According to official Illinois Central records, after retirement four of these locomotives were rebuilt at Memphis, Tennessee, and used to transport locomotive trucks, but no other details are available. (Clifford J. Downey collection.)

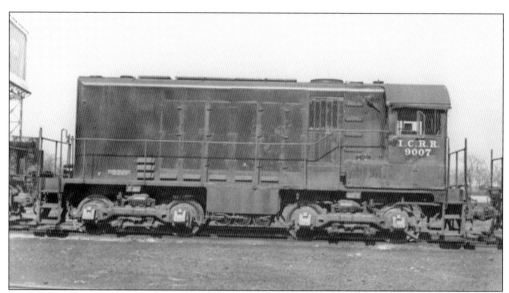

After the "boxcabs," the next diesel-electric locomotives on the railroad were HH600s 9006–9013, built by the American Locomotive Company in June 1935. HH600 was an abbreviation for "High Hood," 600 horsepower. When fully loaded, each locomotive weighed slightly more than 200,000 pounds. No. 9007 was photographed at Twenty-seventh Street in 1948. All eight HH600s spent their entire careers in Chicago, and all were retired in 1951. (Clifford J. Downey collection.)

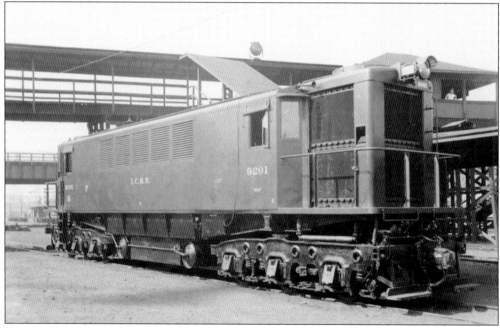

The parade of unusual locomotives continued into 1936. That year General Electric built two locomotives that were externally identical, but mechanically different. No. 9200 (not pictured here) was equipped with a pair of Ingersoll-Rand engines, each rated at 900 horsepower. Sister locomotive 9201 was equipped with a 10-cylinder, 2,000-horsepower engine built by Busch-Sulzer. Both locomotives worked exclusively in the Chicago area until they were retired in 1947.

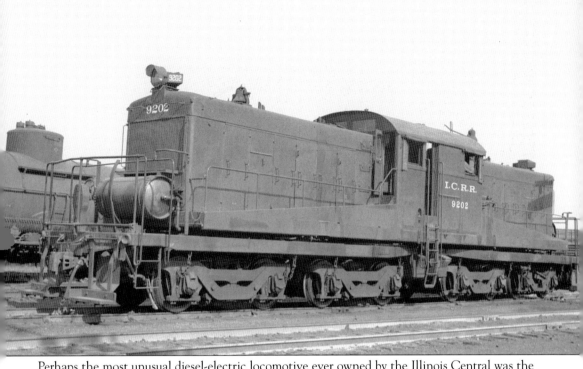

Perhaps the most unusual diesel-electric locomotive ever owned by the Illinois Central was the Model T, purchased only by the Illinois Central. This locomotive was designed by the EMC. But since EMC's plant in La Grange was not complete, the locomotive was built under contract by the St. Louis Car Company. In May 1936, this locomotive was delivered as No. 9201 but was renumbered to 9202 almost immediately after delivery. The car body rested on an articulated under frame, and each half of the under frame rode on a pair of two-axle trucks. At each end of the locomotive there was a 12-cylinder Winton 201A engine producing 900 horsepower. The weight of the machinery caused the frame to sag, so in 1939, triangular braces were added along each walkway. No. 9202 was used mainly to transfer cars between the Illinois Central and other Chicago railroads (the *T* in Model T stood for transfer). In 1950, the locomotive was retired and scrapped. (Charles T. Felstead collection.)

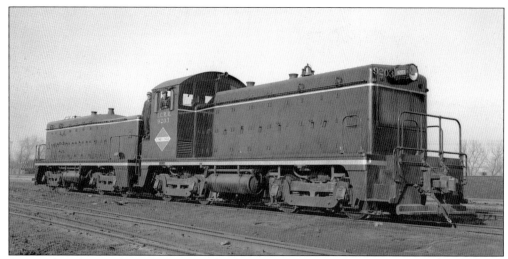

During the 1930s and 1940s, two or more diesel locomotives often had to be coupled together to replace one steam locomotive. This created friction with labor unions, which insisted that every locomotive with a cab have its own crew. Railroads responded by buying "cow-calf" sets for freight yard service. These sets consisted of a standard locomotive (a "cow") mated to a locomotive without a cab (a "calf"). In 1940, the Illinois Central bought three TR sets from EMD. In 1945 and 1949, the railroad bought three TR2 sets, which were identical to the TR. One of the TR sets, 9203A and 9203B, were photographed at Markham Yard around 1950. Illinois Central also bought two TR1 sets, which were completely different from all other cow-calf sets. TR1 9250A-B were photographed at Markham Yard around 1945. (Charles T. Felstead collection.)

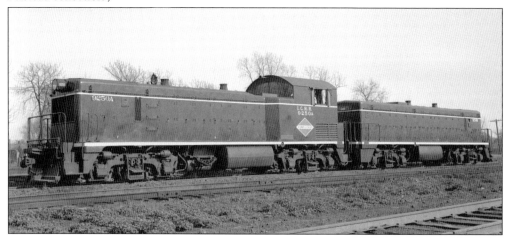

This odd locomotive was built by the EMC in 1930 as a demonstrator. It tested briefly on the Illinois Central, but it is unknown if the railroad seriously considered buying this locomotive, or if management was allowing its railroad to be used as a testing ground. This locomotive was later sold to the Lehigh Valley Railroad. (EMD General Motors.)

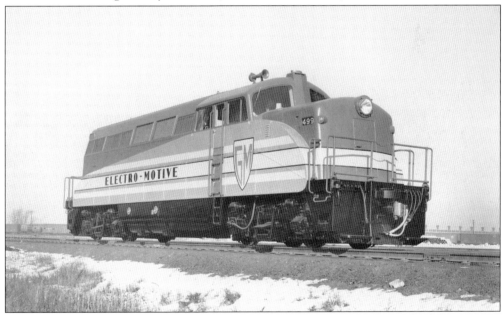

Another odd locomotive that the Illinois Central did not buy was the BL2 built by EMD. A 1948 sales pitch claimed that the Illinois Central could dieselize its Iowa Division with 163 new diesel-electric locomotives from EMD. Five of these diesels would be 1,500-horsepower BL2s, identical to the BL1 demonstrator shown here. Illinois Central passed on the offer. (EMD General Motors.)

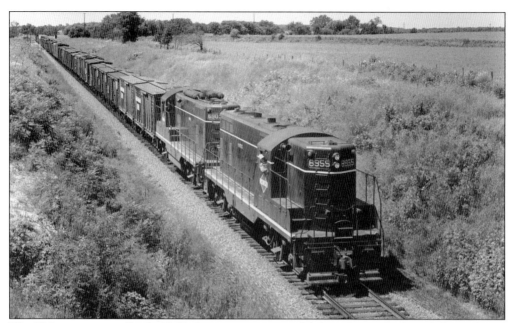

The BL2 was a poor seller for EMD, but it was not a total failure. Using the knowledge gathered during the BL2 program, EMD created the GP7, a 1,500-horsepower road-switcher that turned out to be a huge seller. GP stood for "General Purpose," indicating the locomotive could be used in freight or passenger service. Illinois Central purchased 48 of the GP7s, including this pair built in 1952.

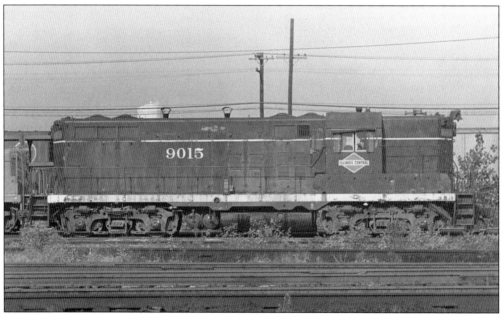

In 1954, the GP7 was replaced by the 1,750-horsepower locomotive. The Illinois Central wound up buying 348 of the GP9s between 1954 and 1959, more than any other customer. In 1967, the railroad began rebuilding these versatile locomotives at its shops in Paducah, Kentucky. GP9 9015 was photographed at Markham Yard around 1970. This locomotive was rebuilt in February 1980, as GP11 8727.

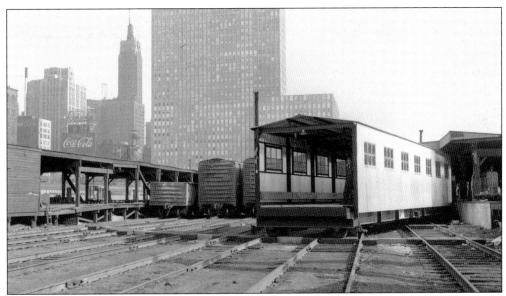

The South Water Street freight house was a beehive of activity. The facility was switched several times daily, and before each move the retractable gangway on the west side of the building had to be moved. This gangway provided access to cars parked on the far side. In this photograph from the late 1950s the gangway has just begun its journey across the tracks (above). According to the large Coca-Cola sign in the background it is 8:34 a.m. The photograph below was taken at 8:37 a.m. as the gangway was completing its journey. In the background is the Prudential Building. The 41-story structure was built between 1952 and 1955 atop Illinois Central trackage.

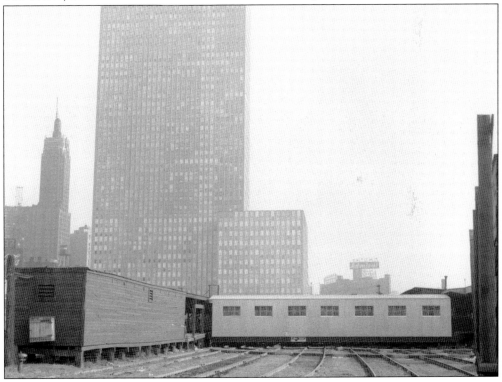

The South Water Street freight house specialized in less-than-carload freight. If a shipper did not make enough merchandise to fill an entire car, his freight could be loaded into a car along with products from other small shippers. At terminals like Chicago, shipments would be split up and rerouted. Here a worker unloads boxes of Pepperell Red Label sheets.

Once the boxes have been loaded on a wagon, a destination code is marked on each box. Boxes that are destined for local Chicago retailers will move to the loading dock, where they will be loaded onto a truck for final delivery. If a box is destined to a distant city, it will be reloaded onto another boxcar for further shipment.

The loaded wagons were moved between railcars by this overhead chain. Each wagon was equipped with a retractable handle. Once a wagon was ready to be moved a worker would raise the handle and engage a hook on the overhead chain. When the wagon reached its destination another worker would grab the handle and pull it off the hook.

A string of wagons are seen making their way down a crowded aisle. During the mid-1900s the Illinois Central lost nearly all of its less-than-carload freight to the trucking industry. In 1946, the Illinois Central moved 1,361,000 tons of less-than-carload freight. By 1956 that figure had fallen to 386,000 tons, and by 1963 it was down to 134,000 tons.

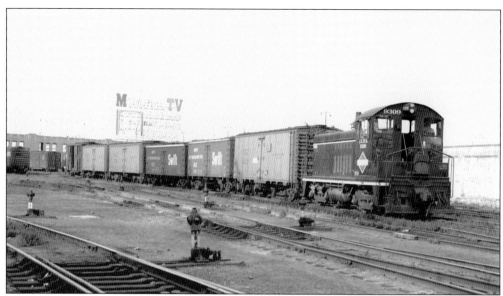

The New York Central Railroad, Chesapeake and Ohio Railroad, and Nickel Plate Road all had busy freight houses along South Water Street. This required switch crews to work quickly and efficiently, especially when moving cars loaded with perishable items. In this photograph taken around 1955, five wooden reefers loaded with meat from Iowa slaughterhouses are being switched at South Water Street by SW9 9309. (Clifford J. Downey collection.)

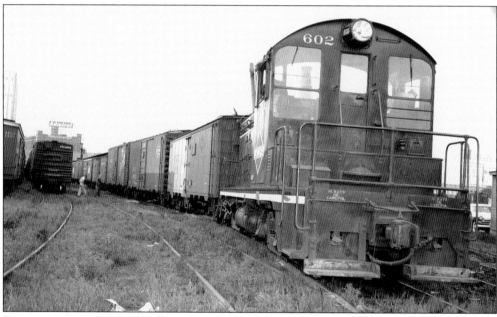

Between 1939 and 1951, the Illinois Central bought 19 SW1 locomotives from EMD. No. 602 was built in 1939 and originally numbered 9016. This locomotive was assigned to Chicago during most of its career and could often be found switching passenger cars at Central Station. In this photograph taken around 1960, No. 602 is switching freight cars at South Water Street. (Clifford J. Downey collection.)

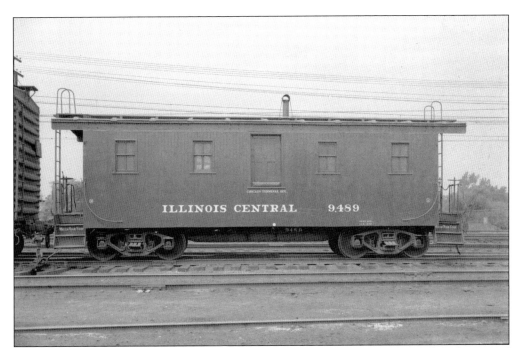

Wooden caboose 9489 was built in 1936 and assigned to the Chicago Terminal. Take note of the door on the side of the caboose. Illinois Central was one of the few railroads to purchase cabooses with side doors. The door was not used as an entrance. Instead it was intended as an opening where the conductor or rear brakeman could lean out and inspect the train.

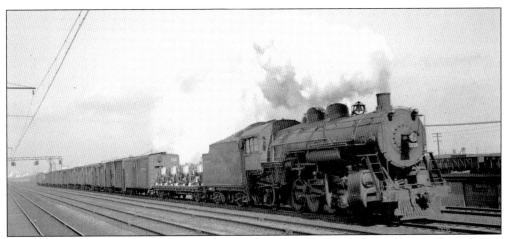

During the steam era the Illinois Central used several different types of steam locomotives to move freight between Chicago and other cities. The 2-8-2 "Mikado" was by far the most prevalent. These versatile locomotives were typically called "Mikes" by crews and rail fans. No. 1558 was photographed hustling a southbound freight along the Main Line around 1950. (Clifford J. Downey collection.)

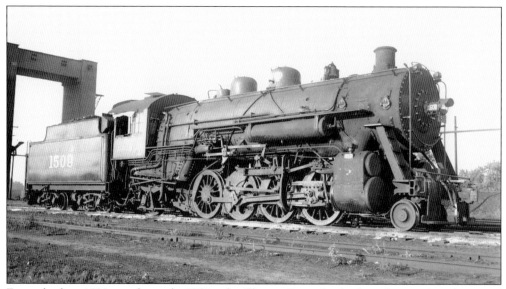

From the late 1930s to the early 1950s, the Illinois Central rebuilt and renumbered most of its steam locomotives at its shops in Paducah, Kentucky. This created considerable confusion among rail fans. Mikado 1509 is shown in this photograph taken at Markham Yard in 1936. This locomotive was rebuilt in July 1942, as 0-8-2 3687. Afterward two different 2-8-2s wore the road number 1509. (Photograph by Charles T. Felstead.)

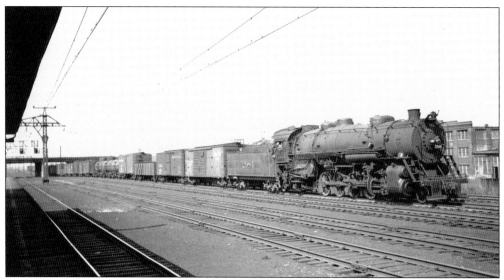

As part of a never-ending search for more powerful locomotives, the Illinois Central bought 125 2-10-2s between 1921 and 1923. On most railroads the 2-10-2s were known as "Santa Fes," but on the Illinois Central the 2-10-2s were known as "Centrals." No. 2984 is seen at Ninety-fifth Street with a southbound freight on May 8, 1937. The Burnside Shops are out of view to the left. (Charles T. Felstead collection.)

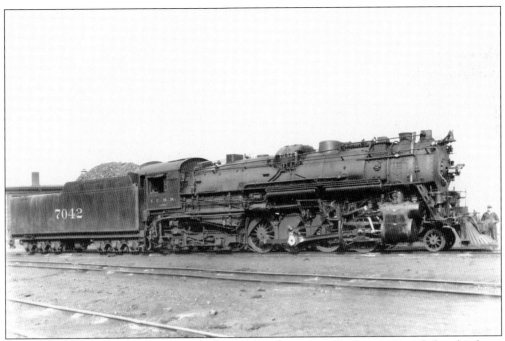

In 1925, the Lima Locomotive Works introduced the 2-8-4, which was intended to be faster and more powerful than other locomotive types. A demonstrator locomotive was tested on the Illinois Central and other railroads. Afterward the Illinois Central bought 50 2-8-4s, plus the demonstrator. Unfortunately, the 2-8-4 never lived up to its potential on the Illinois Central. No. 7042 was photographed at Twenty-seventh Street on February 27, 1931. (Clifford J. Downey collection.)

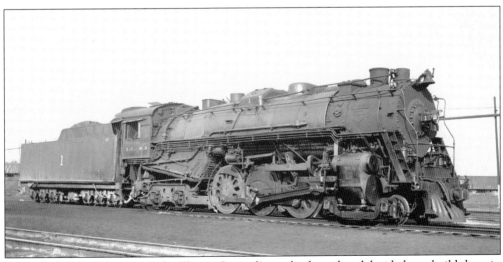

Since the 2-8-4s did not meet the Illinois Central's needs, the railroad decided to rebuild them in hopes of getting what they wanted. In July 1937, No. 7038 was rebuilt at the Paducah, Kentucky, shops as 4-6-4 1. However, the rebuild was not successful and not repeated. The remaining 2-8-4s were later rebuilt, but without major modifications. No. 1 was photographed at Markham Yard in 1938. (Photograph by Charles T. Felstead.)

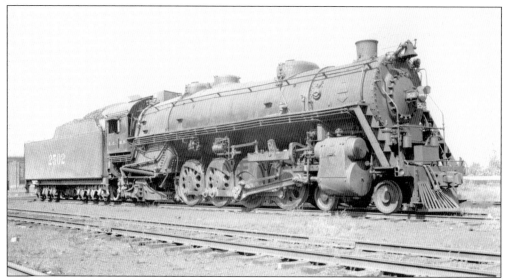

Unlike many of its competitors, the Illinois Central survived the Great Depression without going into bankruptcy. But by the late 1930s the railroad faced another crisis. Its locomotive fleet was quickly wearing out, but management was reluctant to go into debt and buy new locomotives. The railroad instead decided to rebuild its existing fleet of locomotives at its shops in Paducah, Kentucky. The first locomotives to be rebuilt were 56 2-10-2s. At Paducah the boilers from the old 2-10-2s were mated to new frames and drivers to create 4-8-2s 2500–2555. When first rebuilt, 2502 received the 12-wheel tender from a 7000-class 2-8-4, as seen at Markham Yard in July 1937 (above). By May 1938, it had received an eight-wheel tender, as seen in the photograph below, also taken at Markham Yard. (Photographs by Charles T. Felstead.)

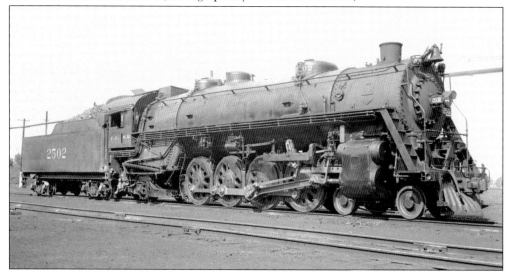

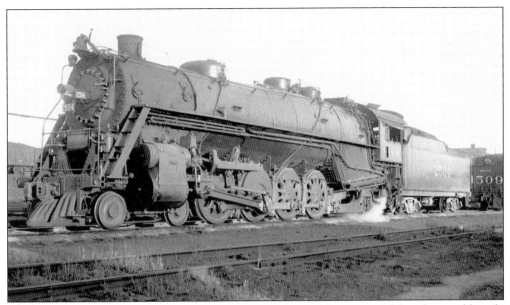

The 2500-class 4-8-2s were an instant success. Not only were they powerful, but they could easily run at speeds over 60 miles per hour. These engines saw service all over the Illinois Central, from Chicago south to New Orleans and west to Iowa. No. 2504 poses at Markham Yard around 1940. This locomotive was retired in December 1959. (Charles T. Felstead collection.)

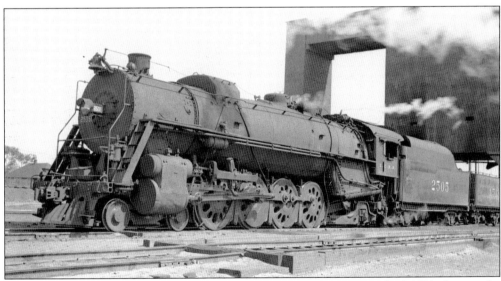

The 2500-class 4-8-2s did have one flaw, namely their tenders. A standard 2500-class tender could carry 24 tons of coal and 11,000 gallons of water. The water capacity was low for a locomotive of this size, requiring frequent water stops or the use of water canteens. No. 2505 was photographed at Markham Yard on June 5, 1946, coupled to water canteen A513. (Charles T. Felstead collection.)

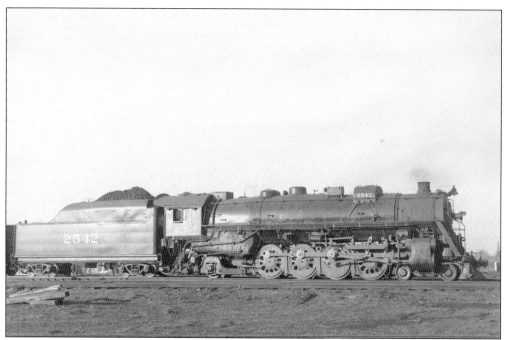

The 4-8-2 2542 awaits its next assignment in this photograph taken around 1950. The tenders of the 2500s were rebuilt from 2-10-2 tenders, which originally held 16 tons of coal. Over the years the sides of the coal bunkers were raised several feet, boosting capacity to 24 tons. The fireman who just refilled 2542's tender has boosted the capacity even more by really heaping on the coal. (Clifford J. Downey collection.)

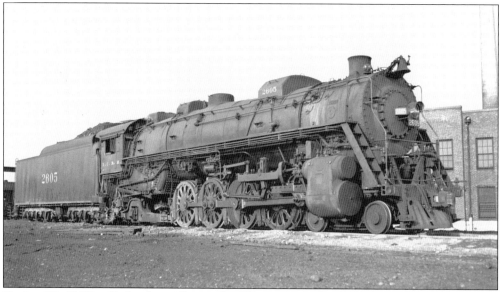

During World War II, freight traffic on the Illinois Central jumped dramatically. To handle this extra traffic the Paducah, Kentucky, shops built 4-8-2s 2600–2619 in 1942 and 1943. These locomotives were patterned after the 2500-class 4-8-2s, but had larger tenders capable of carrying 26 tons of coal and 22,000 gallons of water. No. 2605 was photographed at Markham Yard on August 13, 1950. (Clifford J. Downey collection.)

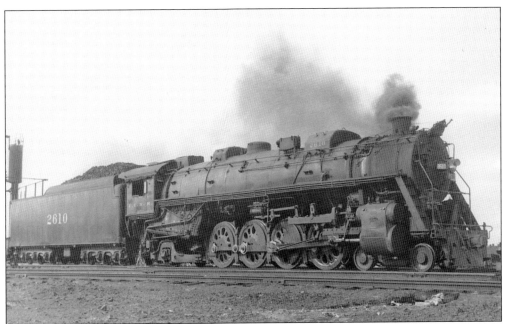

No. 2610 (above) shows off the engineer's side of a 2600-class 4-8-2, while sister 2611 (below) shows off the fireman's side. From the early 1940s to the mid-1950s, the 2500 and 2600-class 4-8-2s were assigned to a "pool" of locomotives that roamed from Chicago south to Bluford, East St. Louis, and Cairo. The locomotives in this pool were responsible for hauling Illinois Central's hottest and fastest freight trains on these lines. They were very successful in this role and could haul more tonnage and run faster than most other steamers on Illinois Central's roster. By early 1956, new GP9 diesel-electric locomotives had bumped the 2500s and 2600s from the hotshot freight trains. Although long gone, the 2600s left a lasting impression on Illinois Central's Chicago-area train crews. (Clifford J. Downey collection.)

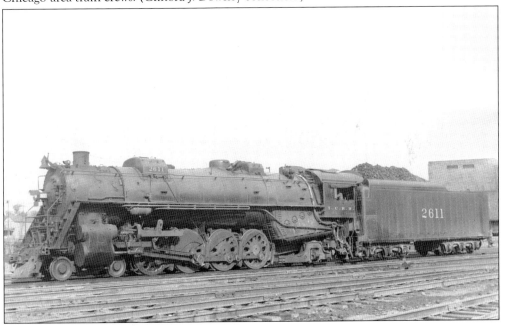

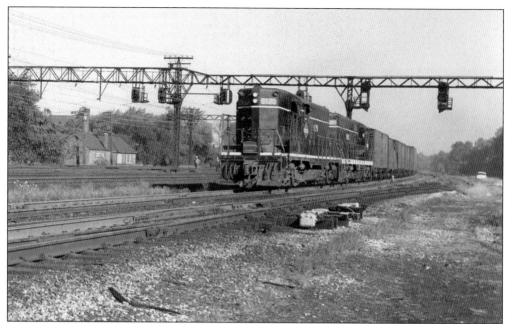

GP9s 9120 and 9095 lead a southbound freight train out of Chicago around 1955. The location is milepost 6.09, near Forty-ninth Street on the Main Line. At this point the Main Line is 10 tracks wide. Six tracks are for use by the electrified suburban trains, two trains are for use by intercity passenger trains, and two are for use by freight trains. (Clifford J. Downey collection.)

GP9s 9063 and 9163, plus GP7 8900 are on the point as a southbound freight rolls through Monee in March 1963. The track through Monee, approximately 37 miles south of Central Station, is officially not part of Illinois Central's Chicago Terminal. However, the four-track Main Line attests that rail traffic through town was very heavy.

The railroad does not shut down when the sun goes down. Powerful flash bulbs capture TR2 cow-calf set 1030A–1030B and its crew while switching freight cars one night in August 1956. Off to the right is the Stevens Hotel. Freight trains carrying perishables were often scheduled to arrive in Chicago during the night. This ensured that fresh fruits, vegetables, and meats would be available to shoppers in the early morning.

Working at night also increased the danger to train crews. This brakeman has stepped between two boxcars to connect a pair of air hoses. His left foot is inside the rail while his right foot is outside the rail. This posture allows him to step back quickly if the cars move. If both feet were inside the rail, he could trip and fall while stepping back.

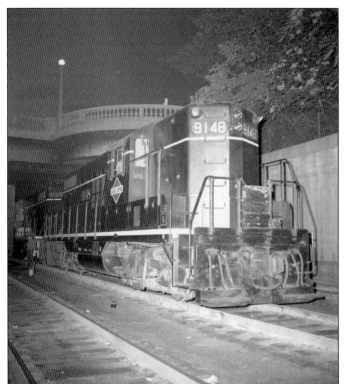

Under the cover of darkness GP9 9148 and her crew are switching cars in the Congress Street freight yard. This yard was located just north of Central Station and had eight tracks with a capacity of 700 cars. It was the receiving and departure point for downtown freight houses. In 1936, this yard handled 320,493 cars, second only to Markham Yard, which handled 941,480 cars.

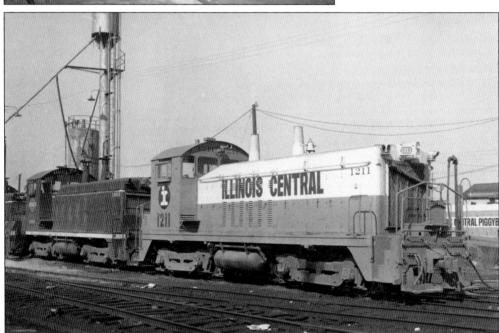

In 1967, the Illinois Central introduced a new paint scheme for its freight locomotives. The new scheme had the top of the car body painted white, while the bottom half of the car body and the cab were painted orange. Letters and numbers were black. SW7 1211 was photographed at Hawthorne Yard in March 1969. (Harold K. Vollrath collection.)

Six

WESTERN LINES

When the Illinois Central Railroad first began operations in Chicago, the railroad had just one route into Chicago. This route was the Chicago Branch running south through Hyde Park and Kensington, and then onward to Centralia. At Centralia, this line connected with the Charter Line, which ran from Cairo north to Freeport and then west to Dunleith.

But the Illinois Central did not have a line running from Chicago to Freeport. As a result, the railroad could not compete effectively for traffic moving between Chicago and Iowa. In 1891, the Illinois Central finally closed the Chicago-Freeport gap by constructing a line of its own. The railroad was forced to twist and wind its ways through the west side of Chicago, since the most desirable routes had already been taken by other railroads.

The Western Lines, as the route to Iowa was known, supplied the Illinois Central with a bountiful supply of freight traffic. Each year the railroad moved thousands of carloads of meat from Iowa slaughterhouses to Chicago. Carloads of fruit and vegetables from western states also flowed over the route. And of course, the Western Lines moved considerable amounts of corn and wheat.

In the 1970s and 1980s, the Illinois Central Gulf (successor to the old Illinois Central) began selling or abandoning routes that were viewed as unprofitable. The Western Lines fell into this category, and on December 24, 1985, the newly formed Chicago Central and Pacific Railroad bought the route from Hawthorne Yard in Cicero west to Iowa.

In a strange twist, the new owners did such a good job of making the Western Lines profitable, the route was purchased back in 1996. Traffic on the line continues to grow under Canadian National ownership, and it is likely that the Western Lines will remain an important link between Chicago and Iowa.

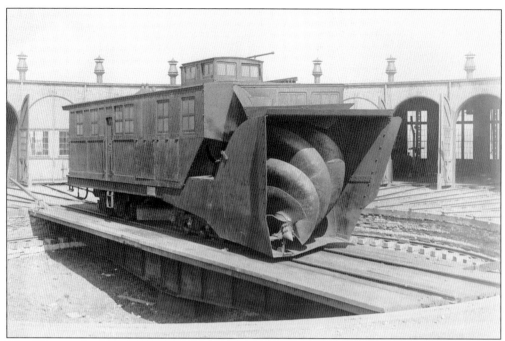

The Western Lines have been hit by numerous blizzards over the years, and a variety of snow-removal techniques have been tested. In 1891, the railroad bought a device called the Jull Centrifugal Snow Excavator. The corkscrew-shaped blade was designed to throw snow to the side of the tracks. It cost $15,000 and saw little action before it was retired around 1910. Mounting plows on the front of steam locomotives was a common snow-removal technique. But these plows were usually ineffective when dealing with packed snow. In such cases the snow had to be dug out by hand or sometimes dynamited. The 2-6-0 731 was built by Rogers in October 1903 and retired in the 1940s. (Clifford J. Downey collection.)

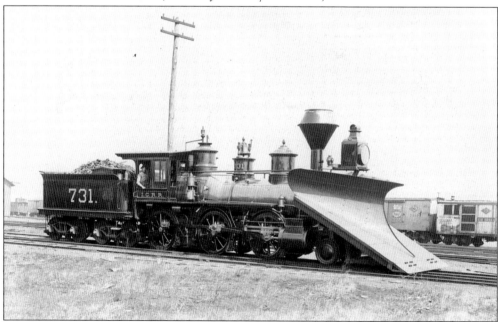

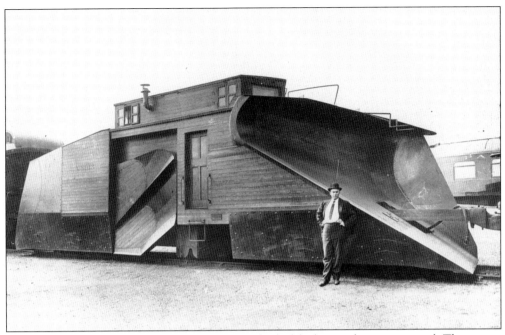

Special plows such as this one were another method of dealing with snow removal. These were coupled in front of a locomotive and then rammed into a snow bank as fast as the crew dared. Ice build-up on the tracks was a major concern, and many plows have derailed after hitting thick patches of ice. This particular plow was photographed around 1900.

During the 1890s, the Chicago Drainage Canal was built to connect the South Branch of the Chicago River with the Des Plaines River at Lockport. This 28-mile canal intersected Illinois Central's Western Lines near Kedzie Avenue. A massive 474-foot steel drawbridge carrying two tracks was built across the canal. This photograph was taken on April 14, 1900, shortly after the bridge was completed.

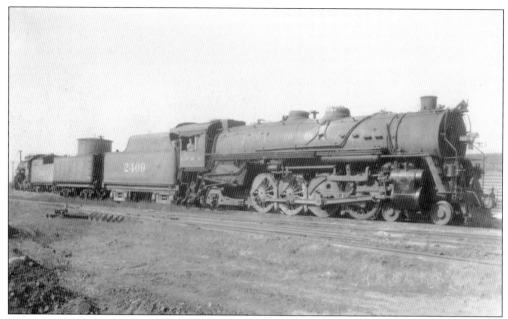

Many freight trains leaving Chicago on the Western Lines were assembled at Hawthorne Yard in Cicero. In 1937, this yard had eight tracks and could hold 429 cars. It is still active today. The 4-8-2 Mountain 2409 poses at Hawthorne on October 24, 1952. This locomotive was built in 1923 for passenger service but was in freight service when photographed. (Clifford J. Downey collection.)

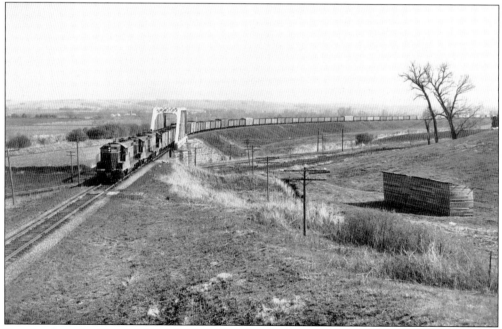

Terrain along the Western Lines is often thought of as being "flat as a pancake." True, there are large stretches of flat prairie land along the route. But the landscape is also dotted with rolling hills that can challenge the most powerful locomotives. This freight has three GP9s and will need all that power to keep the train moving.

On October 26, 1941, the Illinois Central inaugurated the *Land O' Corn* between Chicago and Waterloo, Iowa. Initially the train consisted of two Motorailers built by American Car and Foundry. Lead car 140 was powered by two engines mounted underneath the car body, while trailer 141 was equipped with one engine. This photograph shows the front of car 140 before the train entered service. (American Car and Foundry.)

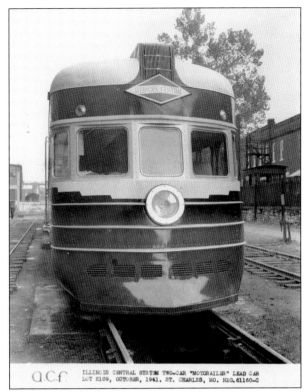

ILLINOIS CENTRAL SYSTEM TWO-CAR "MOTORAILER" LEAD CAR
LOT 2109, OCTOBER, 1941. ST. CHARLES, MO. NEG. 61160-C

This photograph shows the rear end of trailer 141. This car had coach seating for 39 passengers plus an eight-seat lunch counter at the rear of the car. Lead car 140 had 70 coach seats. Motorailers operated as single-car trains on two other Illinois Central routes: Chicago and Champaign, Illinois; and Jackson, Mississippi; and New Orleans. (American Car and Foundry.)

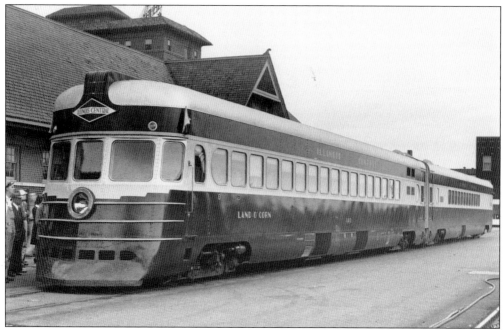

The *Land O' Corn* was photographed at Waterloo, Iowa, during its inaugural run. This black-and-white photograph does not do justice to the train's colorful paint scheme. The bottom of the car was painted blue, with an aluminum band surrounding the windows. Above the windows was a red band, with an aluminum-painted roof. (Photograph by Waterloo Daily Courier.)

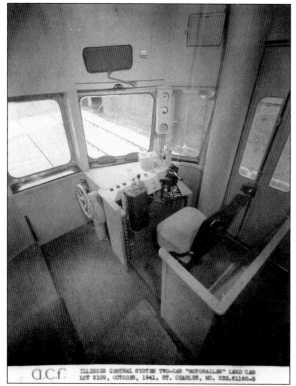

The engineer's stand for the *Land O' Corn* provided very little protection for the engineer. This was sadly illustrated when the train collided with a truck on February 18, 1942, at Plano, and the engineer was killed. Afterward all four American Car and Foundry Motorailers were returned to their builder, and conventional locomotives and cars were assigned to the *Land O' Corn*. (American Car and Foundry.)

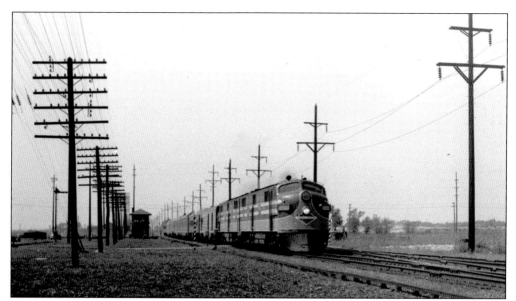

In 1946, the *Land O' Corn* received new streamlined passenger cars. But as this photograph taken around 1950 illustrates, older heavyweight cars did reappear occasionally. The train arrived in Chicago in mid-morning and departed in the late afternoon. The schedule was geared toward persons who wanted to shop or take care of business in Chicago and return home the same day. (Clifford J. Downey collection.)

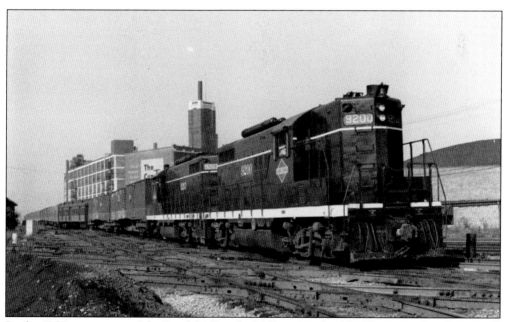

By the 1960s, patronage of the *Land O' Corn* had fallen considerably. The train, though, was still profitable since it was hauling U.S. mail, and it was rescheduled to meet the needs of the post office. On July 1, 1966, the eastbound *Land O' Corn* was photographed at Twenty-first Street. Today's train consists of four containers, four baggage cars, and four passenger cars. (Photograph by Louis A. Marre.)

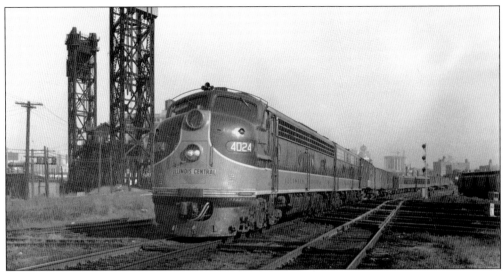

E8A 4024 leads the westbound *Land O' Corn* at Twenty-first Street in October 1966. Upon reaching Waterloo, the passenger cars in the middle of the train will be uncoupled. Then the locomotives and the five containers carrying mail will continue to Fort Dodge, Iowa. The train was discontinued on August 5, 1967, after the U.S. Postal Service cancelled most mail-hauling contracts with the nation's railroads. (Photograph by Bob Schrepfer.)

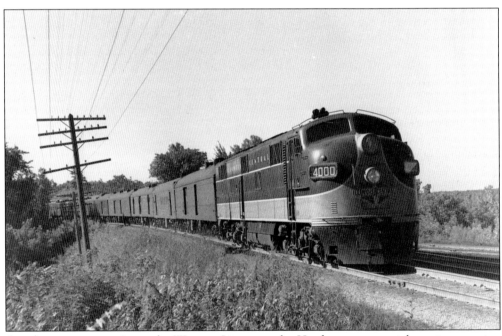

Another passenger train on the Western Lines was the *Hawkeye*, an overnight train operating between Chicago and Sioux City, Iowa. The train was photographed around 1950 at an unidentified location. Leading the train is E7A 4000, built in 1947 as a replacement for wrecked E6A 4000 (see page 47).

Seven

SHOP FACILITIES

To keep its cars and locomotives in top operating condition, the Illinois Central had five major shop facilities in the Chicago area. The Burnside Shops at Ninety-fifth Street handled all major passenger car repairs on the railroad, plus repairs to the electrified suburban cars. The roundhouse at Markham Yard near Homewood serviced locomotives operating in and out of the massive yard. Another roundhouse at Twenty-seventh Street serviced all locomotives used in passenger service. The Weldon Coach Yard, just south of Central Station, handled routine maintenance tasks on all passenger cars.

All four facilities listed above were located along the Main Line, running south out of downtown Chicago. The only major shop facility on the Western Lines was the roundhouse at Hawthorne Yard in suburban Cicero. This roundhouse was not as busy as the roundhouses at Twenty-seventh Street or Markham Yard, but it played a key role in keeping trains running safely on the Western Lines.

The shift from steam to diesel locomotives had a tremendous impact on the railroad's shop workers. The new diesel locomotives required less maintenance than the old steamers. As a result, thousands of shop workers were laid off, not only in Chicago, but all across the system. Boilermakers, blacksmiths, and pipe fitters were hit hard. Many of these men had spent decades sharpening their skills, only to suddenly find themselves out of work.

In the late 1960s, the Illinois Central began making plans to consolidate all of its Chicago shops into a new facility near Markham Yard. It was to be called Woodcrest, taking its name from two nearby communities, Homewood and Hazel Crest. The new $14 million shop opened in phases beginning in early 1970.

After the Woodcrest Shops opened, the ancient roundhouses at Markham Yard, Twenty-seventh Street, and Hawthorne Yard were demolished, along with the Burnside Shops. Today Woodcrest remains the main locomotive repair facility on the former Illinois Central. Although Woodcrest may not have the same atmosphere and appeal as a smoky roundhouse, the facility plays a key role in keeping locomotives running safely and efficiently.

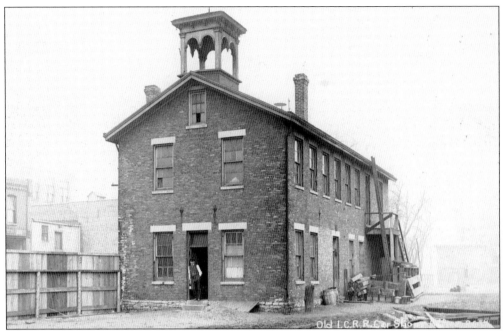

This brick building may look like an old-fashioned schoolhouse, but in reality it was the office building for Illinois Central's car shop at Twenty-sixth Street and South Park Avenue. The photograph is dated April 8, 1903. Within a few years this building will be replaced by a new roundhouse and shop facility at Twenty-seventh Street.

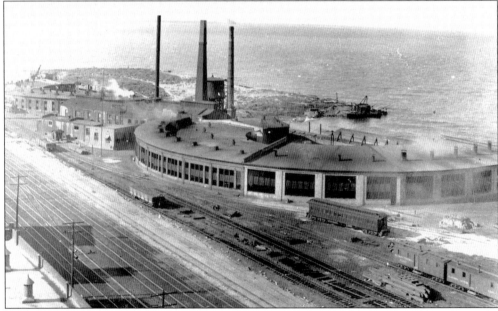

Illinois Central's Twenty-seventh Street roundhouse and shop facility was literally right on the lakefront when constructed in the 1890s. This photograph taken on August 1, 1917, shows that there were once two roundhouses at Twenty-seventh Street. The larger roundhouse at right survived until the late 1960s while the smaller roundhouse barely visible at left was demolished in the 1920s.

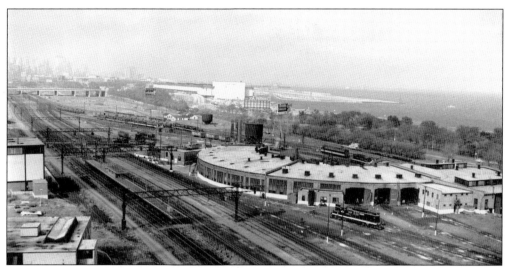

The Twenty-seventh Street roundhouse was the busiest roundhouse on the entire railroad. In the early 1960s, the facility serviced over 1,000 locomotives each month. All passenger trains arriving or departing Central Station had their locomotives serviced at Twenty-seventh Street, as well as all freight trains arriving or departing the Congress Street and South Water Street Yards. This early 1960s view is looking north and shows the "old" McCormick Place.

Crews at the Twenty-seventh Street shops could repair most components on a steam or diesel locomotive. In this photograph a speedometer for an E-unit is being tested after an overhaul. Illinois Central's E-units had a top speed of 117 miles per hour, just below the maximum speed that this speedometer could register. Speedometers were linked to a recorder that could provide information following an accident.

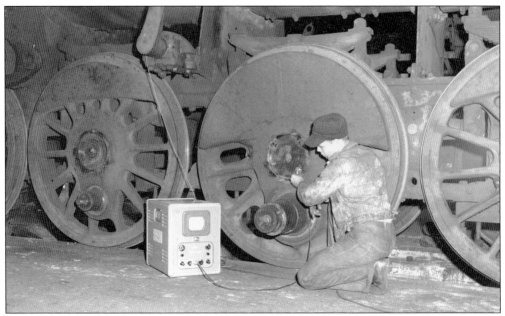

Metal fatigue has always been a major concern of the railroad industry. Unfortunately, most flaws in a metal object are not visible to the naked eye until the object breaks. Over the years several techniques have been developed to analyze metal parts and detect hidden flaws. This photograph from the 1950s shows a worker at the Twenty-seventh Street roundhouse using a Reflectoscope to inspect a steam locomotive driver.

Railroading was, and still is, a dangerous occupation. The 2-8-2 Mikado 1679 is seen in this undated photograph after a collision has smashed the headlight and ripped off the pilot (or "cow catcher"). The use of radios for communication and improved signal systems have dramatically reduced the number of collisions, as well as employee injuries and deaths. (Clifford J. Downey collection.)

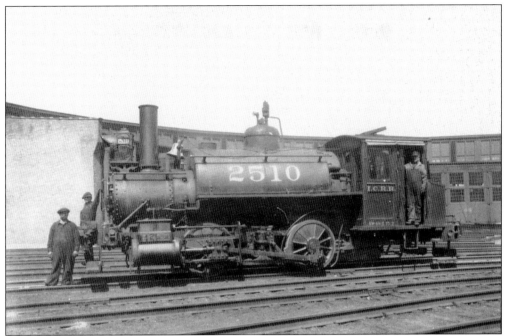

The 0-4-0T 2510 and its crew pose for a photograph at Markham Yard around 1930. This diminutive locomotive was built by the Illinois Central in September 1882 and originally was numbered 20. In February 1917, it was rebuilt as a "shop goat" to move locomotives around roundhouses and engine facilities. Thanks to its short length, 2510 could fit onto a turntable with another locomotive. (Clifford J. Downey collection.)

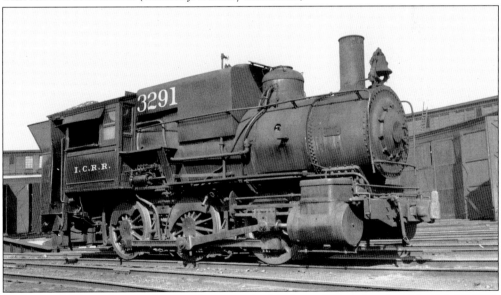

Shop goat 2510, in the top photograph, was retired in June 1935 and replaced by 0-6-0T 3291. This particular locomotive was rebuilt in July 1943, from 2-6-0 431. Prior to rebuilding, No. 431 spent several years at the locomotive test plant at Purdue University. The University of Illinois at Champaign-Urbana also had a locomotive test plant, and the Illinois Central worked closely with both universities. (Clifford J. Downey collection.)

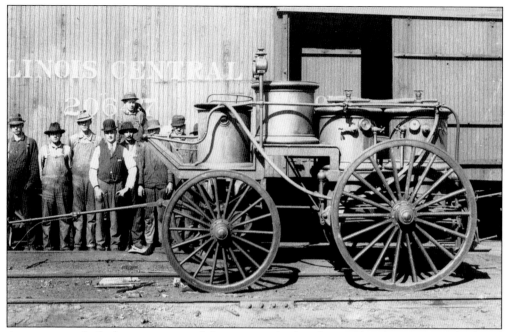

A vast array of oils, lacquers, paints, lubricants, and other flammable substances can be found in nearly every shop facility. As a result, shop employees need to be trained on how to prevent fires, and be ready to extinguish any fires that should start. This photograph taken around 1900 shows a fire crew at the Burnside Shops with an early steam-driven pumper.

Three wagons filled with dirt are being towed around the Burnside Shops in this photograph from the mid-1920s. The tires on the tractor and wagons are made of solid rubber so they cannot be punctured and lose air when passing over nails, glass, and other sharp debris.

Burnside Shops was the major passenger car–rebuilding shop on the Illinois Central. The crews had the training and tools to rebuild almost any passenger car. But it is doubtful that much can be done to save this wooden car, known as a combine. Passengers sat in the left half of the car, while the right half of the car had a baggage compartment. (Clifford J. Downey collection.)

If a passenger car was too damaged or worn out to be repaired, an Authorization For Retirement (AFR) was issued and the car was scrapped. A careful accounting was made of all parts salvaged for reuse and the value of all parts that went to scrap. Wooden office car 4, built in the late 1800s, is about to be stripped apart. (Clifford J. Downey collection.)

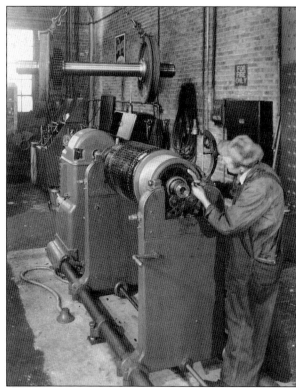

The Burnside Shops were also the main repair facility for Illinois Central's electric suburban cars. In this photograph from the 1940s a worker is rebuilding part of a traction motor. Once the traction motor is reassembled it will be mated to an axle on the car. The motor will turn the axle, thus propelling the car. (Kaufmann and Fabry Company.)

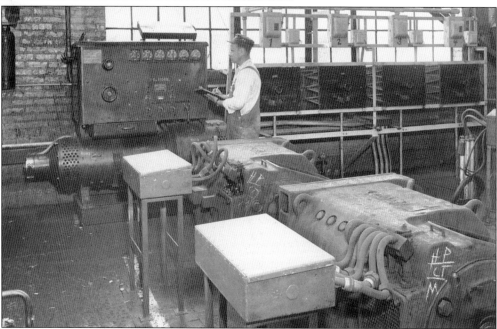

In this undated photograph a worker is standing next to a test panel that is connected to rebuilt traction motors from suburban cars. It is presumed that the worker is testing the rebuilt traction motors. But in reality the photograph is staged, for the fuse boxes are turned off, the test panel is not energized, and all gauges are showing zero. (Kaufmann and Fabry Company.)

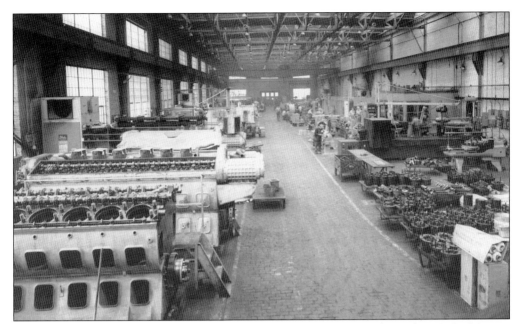

The Burnside Shops also began rebuilding diesel-electric locomotives in the 1940s. Massive engine blocks from diesel-electric locomotives are visible at left in this undated photograph. On the right are cylinder liners, piston heads, and connecting rods that are being refurbished and will eventually be installed in the engine blocks. Burnside Shops was demolished in the early 1970s, and the site was redeveloped as a community college.

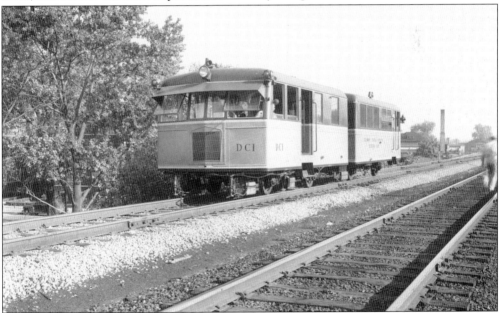

During the early history of the railroad industry, broken rails were a leading cause of derailments. Then in the 1920s several methods were developed for testing rails and identifying cracks and other flaws not visible to the naked eye. Several railroads, including the Illinois Central, adopted the new technology and built their own test cars. Car DC1 was photographed around 1950 near Homewood.

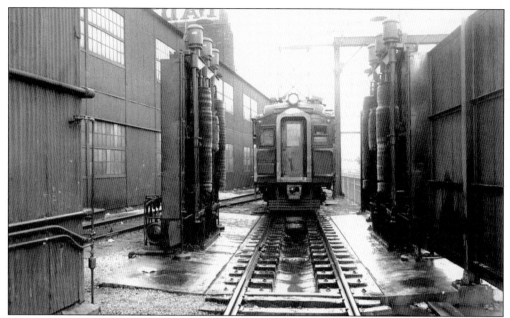

A wash rack was installed at the Weldon Coach Yard in the 1940s to clean Illinois Central's suburban cars. This rack was identical to another wash rack at Weldon Yard used to clean passenger cars (see page 50). Intercity passenger cars were usually washed after each run, but the suburban cars were usually washed only when they were shopped or if the cars were particularly grimy. (Whiting Corporation.)

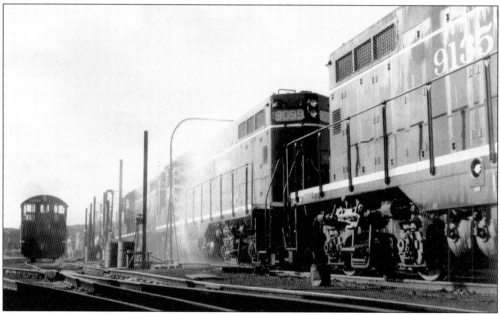

Not only were diesel locomotives easier to maintain than steam locomotives, they were easier to wash. Steam locomotives were washed using high-pressure hoses and brushes with long handles. After the last of the steam locomotives left Chicago, a drive-through wash rack was installed at the Twenty-seventh Street roundhouse. Three GP9s are going through the wash rack on August 20, 1958. (Photograph by Bruce R. Meyer.)

Maintaining the overhead wires that supplied electricity to the electrified suburban cars was just as important as maintaining the cars. There were several hundred miles of wires to maintain. Crews initially used wooden cars such as these to access the wire.

The old wooden cars were equipped with manual cranks to raise and lower the platform. By the 1940s the old wooden cars were replaced with newer cars equipped with hydraulic lifts. The platforms were towed by self-propelled motorcars. Safety was a top priority, since the crews worked in close vicinity to busy tracks and high-voltage wires.

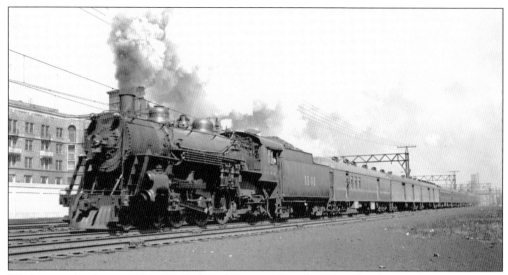

Working in the shops was hard and often dangerous. But thanks to the shop workers, the Illinois Central was able to run trains that were both fast and safe. In May 1937, a southbound passenger train is seen rushing out of town behind 4-6-2 1141. The train's speed has caused the front of the locomotive to appear blurred. (Charles T. Felstead collection.)

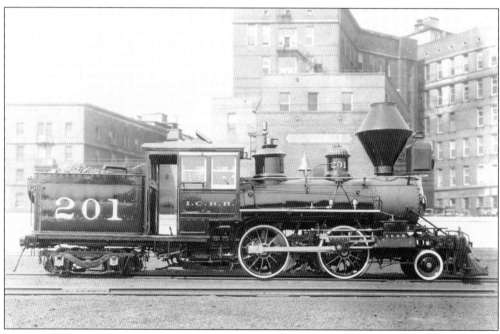

Shop workers were often called upon to perform special tasks. One of these was the refurbishment of 2-4-4T 1401. After the railroad electrified its suburban trains in 1926, locomotive 1401 was kept by the railroad and restored to a late-1880s appearance. The locomotive was renumbered 201, one of its earlier numbers, to avoid conflict with a 2-8-2 that was still active.

Eight

THE RAILROAD RUNS ON PEOPLE POWER

There can be no doubt that the Illinois Central operated some of the finest passenger trains found on any railroad, and that its freight operations were vitally important to Chicago's commerce. But often overlooked is the fact that if it were not for the railroad's employees, nothing could be accomplished. The *Panama Limited* did not propel itself down the tracks at 100-plus miles per hour by magic. Instead there was an engineer inside the cab of the lead locomotive. It was the engineer's duty to safely operate the locomotive so the train stayed on time. Back in the passenger cars, the conductor and a crew of porters, waiters, and cooks worked long hours to take care of passenger needs. These crews were often away from home for several days at a time.

Meanwhile, brakemen and conductors worked in snow, sleet, or rain to deliver freight cars to factories and warehouses around the Windy City. Until 1907 there was no limit on the number of hours that a train crew could be forced to work. In 1907, a new federal law set the limit at 16 hours. It has since been lowered to 12 hours, with a minimum of 8 hours rest between shifts. During busy times, it is not uncommon for train crews to work a full 12 hours, then be called back immediately after their 8-hour rest period. This cycle may continue for days, weeks, or months.

During the early 1900s, the Illinois Central employed approximately 11,000 employees in the Chicago area. By 1938 that figure had been trimmed to 7,800, mostly by purchasing cars and locomotives that required less maintenance. Not all of the railroad's employees were directly involved in train operations. Approximately 3,000 employees worked in the railroad's headquarters at Central Station.

Illinois Central employees tended to work in anonymity, and the public got to meet only a select few. But whether an employee was an accountant, engineer, brakeman, vice president, welder, or ticket agent, he or she played a vital role in keeping the railroad operating smoothly in Chicago.

In the late 1800s, railroads were empowered by federal law to form their own police forces to protect passengers and prevent theft. Railroad policemen had (and still have) the authority to carry weapons and arrest persons. This officer, photographed around 1900, was an Illinois Central policeman on the Chicago Terminal. Railroad policeman were known as "bulls" for their often-fierce behavior.

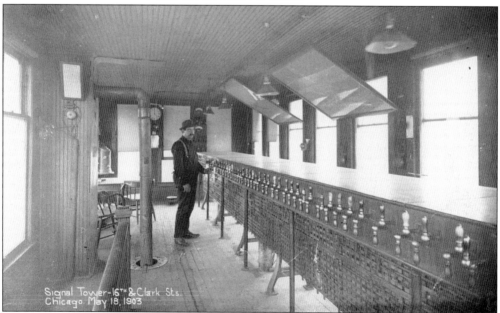

Until the mid-1900s, the Illinois Central employed hundreds of tower men in the Chicago area. These men controlled traffic at junctions with other railroads, switched trains from one track to another as directed by a dispatcher, and copied train orders that were given to train crews. This photograph was taken on May 18, 1903, inside the tower at Sixteenth and Clark Streets. Automation has eliminated most tower men jobs.

Central Station was intended to house all employees in the railroad's headquarters. But after the railroad ran out of space at Central Station, most employees in the accounting department were moved to a new nine-story office building at Sixty-third Street. The steel framework is nearly complete in this view from February 1918. The new building was located right next to the Sixty-third Street suburban platform.

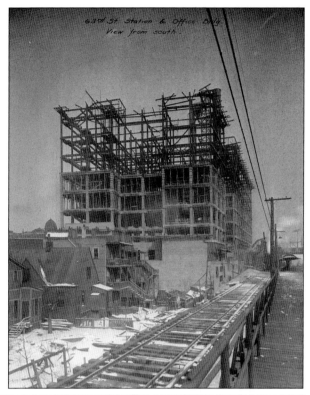

This group of stern-looking workers at the Sixty-third Street office building was photographed in May 1918. The accounting department may have had one of the most difficult jobs on the railroad. Accounting practices had to conform with standards established by the Interstate Commerce Commission. There were hundreds of different freight rates, and shippers were quick to complain if the wrong rate was used to calculate freight charges.

Depending on their job, there was a wide variety of dining opportunities available to Illinois Central employees in the Windy City. Train crews and shop employees typically carried a lunch bucket, but that does not mean they ate cold food all the time. These employees were well known for their creativity and could adapt nearly any hot surface for use as a stove. Meanwhile, employees at the Central Station complex and the Sixty-third Street office building had access to cafeterias. The dining room and bakery at Sixty-third Street are seen in these two photographs taken in 1918. At the time there were approximately 750 employees working at the Sixty-third Street building.

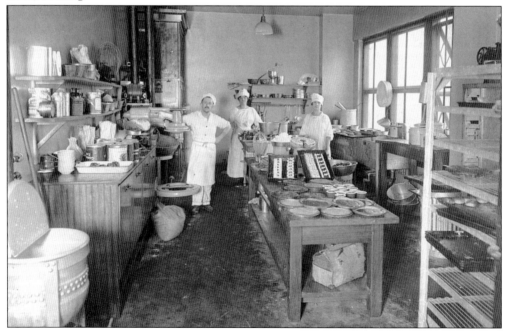

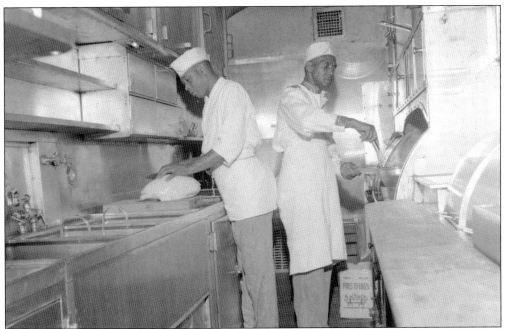

Two cooks literally work side-by-side as they prepare meals in an Illinois Central dining car around 1960. The kitchen was equipped with a propane-burning stove, but a box of Pres-To-Logs is on hand as an emergency backup. A diner with a full crew typically had a chef, three cooks, a porter, and four or five waiters.

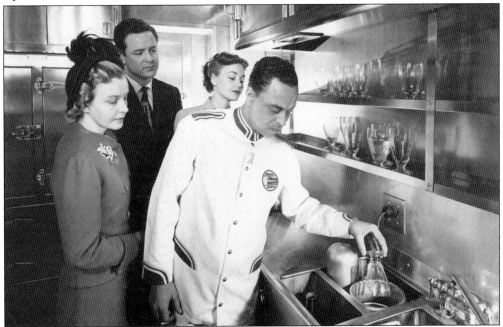

Over the years the Illinois Central released many publicity photographs featuring its employees, some of which bordered on being silly. This photograph was taken around 1955 aboard one of the railroad's diners. Two women and a man are watching attentively as a waiter prepares to insert a glass into a Hamilton Beach washing machine. (Photograph by Victor T. Fintak Studios.)

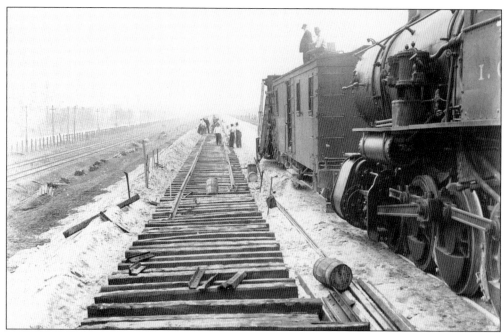

Many employees were engaged in work that was hot, dirty, and dangerous. This photograph was taken at Kensington when the tracks were being elevated above level. Throughout the system the railroad employed track gangs, and each gang was assigned to a particular section of the railroad. By the 1960s most of these workers had been replaced by mechanized track machines.

Around 1920 a shop worker was photographed at the Burnside Shops with a motorized cart loaded with rubber air hoses. Black workers were largely restricted to manual tasks such as this one. A handful of black workers were employed as locomotive firemen or machinist helpers, but these men generally were kept from advancing to engineer or machinist positions.

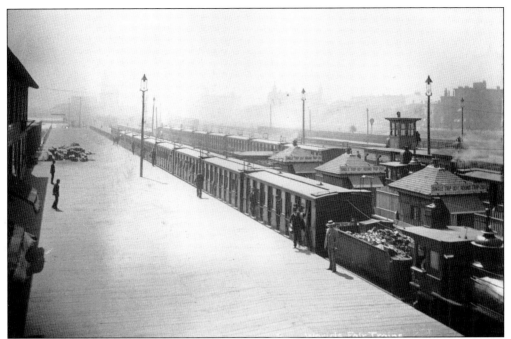

The World's Columbian Exposition of 1893 was held in Jackson Park next to Illinois Central's tracks. A passenger could ride one way from Van Buren out to the fair grounds for 10¢ (a round trip cost 20¢). This photograph shows one of the fair trains loading at Van Buren Street.

As part of the planning for the Columbian Exposition the Illinois Central extended suburban service to the small village of Blue Island. This single-track branch split away from the Main Line south of Kensington and ran four miles to Blue Island. Opened on May 1, 1893, this line is still in service. This photograph was taken around 1900.

In 1926, the Illinois Central electrified its suburban service. Over $11 million was spent on 140 motorized suburban cars and 140 unpowered trailers. Several million more dollars were spent on new stations, track relocation, and stringing overhead wires to supply electricity to the new cars. On the morning of June 26, 1958, a northbound suburban train zips past Central Station. (Photograph by Bruce R. Meyer.)

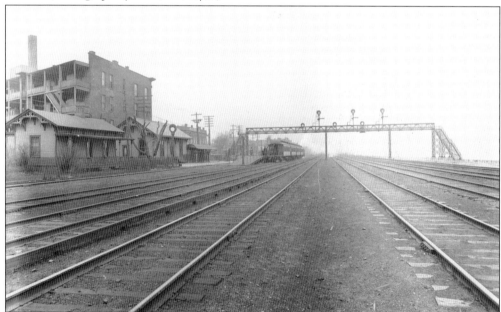

Illinois Central's suburban service is now operated by METRA. The cars are air-conditioned, well lit, and a far cry from the "good ol' days." One thing that has not changed is the fast schedules and the hordes of commuters that fill the trains each rush hour.

The practice of putting advertisements aboard mass transit vehicles is not new. This card dated September 1, 1911, lists the rates for advertising aboard Illinois Central's suburban trains. An advertiser who signed a 12-month contract could advertise aboard 175 cars at a cost of $78.75 per month. According to the card, the Illinois Central's service was "The Greatest Suburban Line In Chicago." (Clifford J. Downey collection.)

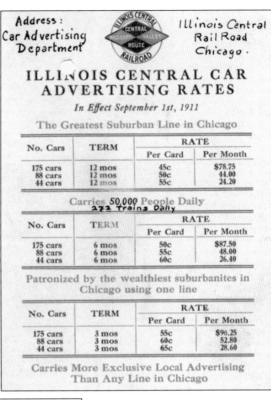

Address:
Car Advertising
Department

Illinois Central
Rail Road
Chicago.

ILLINOIS CENTRAL CAR ADVERTISING RATES

In Effect September 1st, 1911

The Greatest Suburban Line in Chicago

No. Cars	TERM	RATE	
		Per Card	Per Month
175 cars	12 mos	45c	$78.75
88 cars	12 mos	50c	44.00
44 cars	12 mos	55c	24.20

Carries 50,000 People Daily
272 Trains Daily

No. Cars	TERM	RATE	
		Per Card	Per Month
175 cars	6 mos	50c	$87.50
88 cars	6 mos	55c	48.00
44 cars	6 mos	60c	26.40

Patronized by the wealthiest suburbanites in Chicago using one line

No. Cars	TERM	RATE	
		Per Card	Per Month
175 cars	3 mos	55c	$96.25
88 cars	3 mos	60c	52.80
44 cars	3 mos	65c	28.60

Carries More Exclusive Local Advertising Than Any Line in Chicago

Around 1955, a group of school kids was photographed during a tour of Markham Yard. The kids are seen climbing down from SW7 9313 and sprinting off to their next stop along the tour. Tours like this one helped give the railroad a positive image. This was very important during the 1950s as the railroads fought to save their passenger and freight traffic.

As part of their tour the children also visited the cab of 4-8-2 2552. This young man is obviously enjoying the experience and perhaps is dreaming of becoming a steam locomotive engineer when he grows up. But that dream will go unfulfilled, for after 1956 the Illinois Central quit operating steam locomotives in the Chicago.

The kids appear mesmerized as they tour the Markham Yard roundhouse. To the left is 2-4-4T 201. This is the same locomotive pictured on page 110. After the Illinois Central quit running steam locomotives into Chicago, the Markham roundhouse was used to maintain diesel locomotives. It was replaced by the new Woodcrest Shops and was demolished in the early 1970s.

Nine

Two Decades
of Change

The 1950s and 1960s was a period of great change for the Illinois Central Railroad. In 1956, the railroad operated its last steam locomotives in the Chicago area. Then in the 1960s the railroad had to deal with a decline in both its freight and passenger business. After dropping several passenger trains during the mid-1960s, the Illinois Central got out of the intercity passenger service altogether on May 1, 1971, when the remaining trains were transferred to Amtrak.

For a few months Amtrak continued to operate out of Central Station. But then Amtrak decided to consolidate all of its Chicago trains at Union Station. The last passenger train left Central Station on March 5, 1972. Then during the winter of 1973–1974 the railroad's headquarters moved to a new office building, and soon afterward Central Station was demolished.

The railroad also changed greatly due to a merger. In 1962, the Illinois Central began merger talks with the Gulf, Mobile and Ohio Railroad. The two railroads served many of the same cities, and it was thought that by combining resources and eliminating duplicate facilities, the railroads could reduce costs and become a stronger railroad. A formal merger agreement was signed in 1967, and the merger was consummated on August 10, 1972. The new railroad was called Illinois Central Gulf.

Unfortunately, the merger did not go as expected. Large portions of the railroad were sold or abandoned during the 1970s and 1980s. One of the routes that was sold was the Western Lines from Chicago west to Iowa. To many in the railroad industry, the Illinois Central Gulf seemed to be in turmoil.

But like the mythical Phoenix, the railroad was destined to rise from the ashes. In 1988, the railroad gained its independence from its parent company and took its old name, Illinois Central. A new management team came in, and within a few short years the Illinois Central had became one of the most efficient railroads in the industry. Today the railroad is owned by the Canadian National Railway, but it remains an important part of the Chicago rail scene.

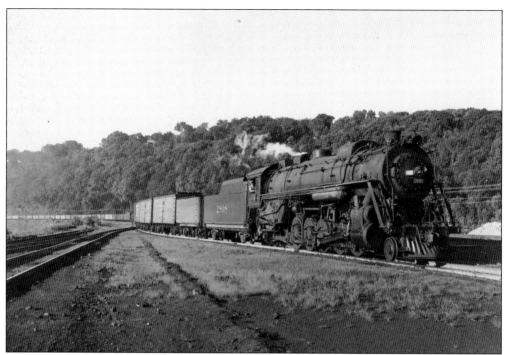

In the eyes of the public, the most noticeable change on the Illinois Central during the 1950s was the shift from steam to diesel locomotives. The 2-10-2 2808 was photographed in Iowa around 1950 with a Chicago-bound train. The wooden reefers are filled with meat from Iowa slaughterhouses. In a few years new GP9 diesel locomotives will take over, and the 2800-class 2-10-2s will move to the Kentucky Division.

Between 1950 and 1953, the Illinois Central bought 48 GP7s from EMD for service around Chicago, in Iowa, and on the far southern end of the system. No. 8900 was photographed shortly after it was built in November 1950. That tiny road number painted on the long hood was soon replaced with a much larger number. (Clifford J. Downey collection.)

Between 1952 and 1955, the Prudential Insurance Company built its new 41-story office building along Randolph Street atop Illinois Central tracks. Prudential paid the Illinois Central over $2.2 million for air rights, which gave Prudential the right to build atop Illinois Central's property, but the railroad retained ownership of the land. This photograph was taken on June 22, 1955, as the skyscraper was nearing completion.

As early as the 1920s the trucking industry was taking business away from the railroads. The railroad industry fought back by establishing "trailer on flat car" service, or TOFC. Highway trailers were loaded onto flatcars and hauled by rail for most of their journey. The trailers were then unloaded for final delivery. Several TOFC trailers are seen at South Water Street in this photograph taken around 1960. (Photograph by Hedrich-Blessing Studio.)

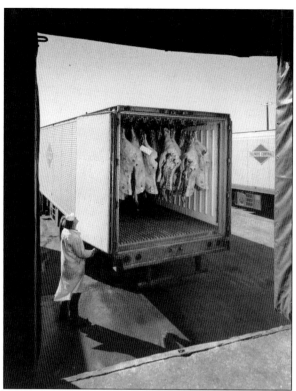

Hauling meat from Iowa slaughterhouses was very lucrative for the Illinois Central, and the railroad competed strongly against other railroads for this business. Then in the 1950s the railroad faced additional transportation from refrigerated highway trucks. Illinois Central responded by buying its own fleet of refrigerated trucks to win back customers that had switched to trucks. A loaded trailer is inspected at a Chicago-area meat store. (Photograph by Hedrich-Blessing Studio.)

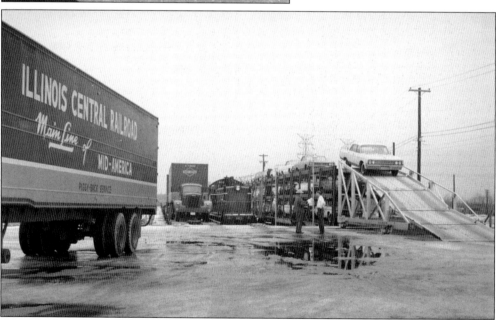

Prior to the 1950s, boxcars were commonly used to transport new cars and trucks. But competition from the trucking industry forced the railroad to change its ways. New railroad cars capable of holding two levels of trucks or three levels of cars were developed. Wildwood Yard, at 130th Street between Kensington and Riverdale, was the site of a major automobile unloading facility. (Photograph by Hedrich-Blessing Studio.)

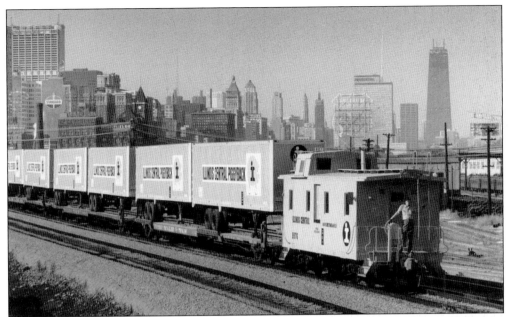

For many years there was no easy way for a freight train to go from Markham Yard, near Homewood on the south side of Chicago, to the Western Lines. That changed in July 1968, when a new connection was built near Central Station. Afterward, several trains that once originated at Hawthorne Yard in Cicero were shifted to Markham Yard. This photograph of a piggyback train was taken around 1970.

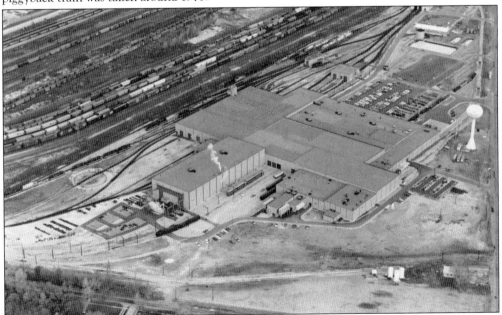

In the mid-1960s, planning began for a new shop facility to replace the antiquated shops at Burnside (Ninety-fifth Street) plus the roundhouses at Twenty-seventh Street, Markham Yard, and Hawthorne Yard. The new shop was built at the southern end of Markham Yard. Called Woodcrest, this new facility cost approximately $14 million to build. The first segment of the facility opened for business in early 1970.

The coaling tower at Markham Yard is being demolished in this photograph. This mammoth concrete structure could refuel locomotives parked on six tracks. Countless locomotives were photographed near this structure, and some of those photographs appear in this book.

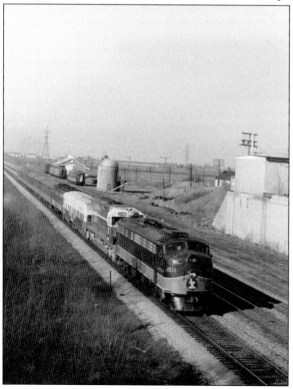

During the 1960s numerous changes were made to the Illinois Central's passenger service. One of the affected trains was the *Seminole*, which originally operated from Chicago south to Jacksonville, Florida. Service between Carbondale and Jacksonville was discontinued on June 3, 1969, and the remaining Chicago-Carbondale train was renamed the *Shawnee*. On April 13, 1971, the southbound *Shawnee* was photographed at Monee. (Photograph by Bruce R. Meyer.)

After 81 years of service, Central Station was demolished in 1974. In this view looking due north, the wrecker's ball is standing amid debris from the train shed. The waiting room is to the right, and the clock tower is in the distance. The entire Central Station complex was torn down, including the station itself plus the annex building and the Dowie Building.

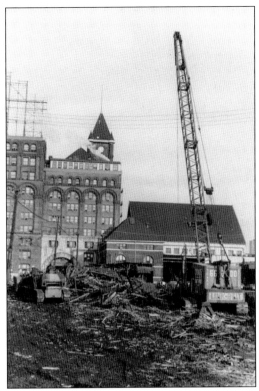

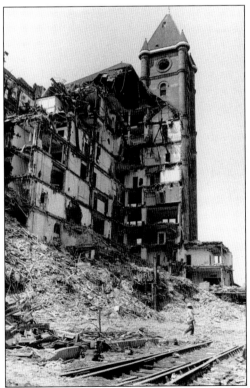

The clock tower was the last part of the Central Station complex to be razed. Once demolition was complete, the site sat empty for several years. Then beginning in the late 1990s the area was redeveloped for residential purposes. A townhouse complex called Central Station and a 40-story luxury apartment complex called Sky 55 now occupy the site.

Across America, People are Discovering Something Wonderful. Their Heritage.

Arcadia Publishing is the leading local history publisher in the United States. With more than 3,000 titles in print and hundreds of new titles released every year, Arcadia has extensive specialized experience chronicling the history of communities and celebrating America's hidden stories, bringing to life the people, places, and events from the past. To discover the history of other communities across the nation, please visit:

www.arcadiapublishing.com

Customized search tools allow you to find regional history books about the town where you grew up, the cities where your friends and family live, the town where your parents met, or even that retirement spot you've been dreaming about.